IMAGES
of Sports

BOXING IN
SAN FRANCISCO

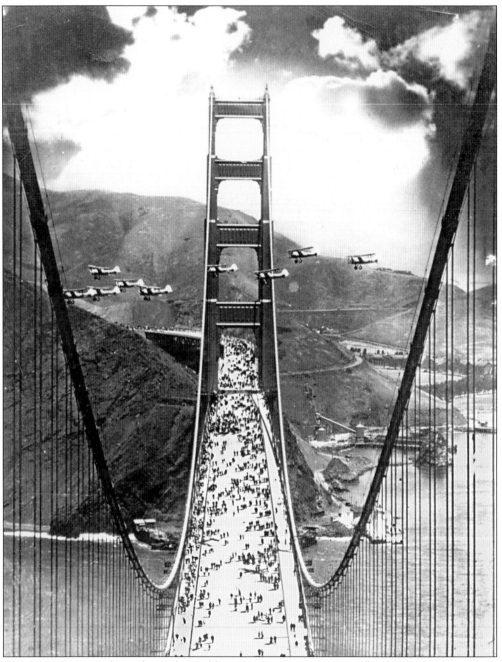

This May 27, 1937 photo shows the Golden Gate Bridge on opening day, or "Pedestrian Day."

To my father, Frank D. Somrack, my first sports idol and the one who introduced me to the "sweet science;" and to my mother, Molly, who introduced me to the arts, stood by me, and always cheered me on. This book was written for them.

IMAGES
of Sports

BOXING IN
SAN FRANCISCO

F. Daniel Somrack

ARCADIA

Copyright © 2005 by F. Daniel Somrack
ISBN 0-7385-2886-2

Published by Arcadia Publishing
Charleston SC, Chicago IL, Portsmouth NH, San Francisco CA

Printed in Great Britain

Library of Congress Catalog Card Number: 2004103394

For all general information contact Arcadia Publishing at:
Telephone 843-853-2070
Fax 843-853-0044
E-mail sales@arcadiapublishing.com
For customer service and orders:
Toll-Free 1-888-313-2665

Visit us on the internet at http://www.arcadiapublishing.com

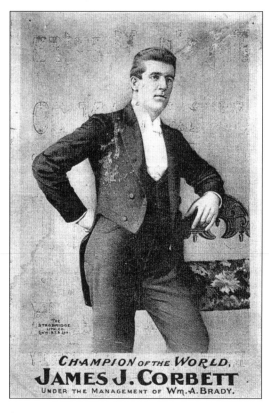

This c. 1900 trading card features
heavyweight champion James J. Corbett.

CONTENTS

ACKNOWLEDGMENTS

I would like to thank the many friends and associates who have helped make this book possible. The following is a short list of individuals who have contributed in their own special way in the creation of this book.

To J.J. Johnston, who taught me the difference between "The Boston Gob" and "The Barbados Demon." Thanks for your friendship and support. Gary Phillips, my deep appreciation for your historical information on San Francisco and your generous contribution of photographs. With great admiration, I thank my friends and idols who continue to inspire me: Muhammad Ali, Teofilo Stevenson, and Carlos Palomino. Special thanks to those individuals who helped along the way: Joseph M. Medawar, John M. Brown, Dr. Jack Breslin, Robert Princic, Patrick J. Keelan, Geoff Strain, Omer W. Long, Joe Hybl, William F. Keelan, Enrique Ferreiro, Tom Patti, George McCatty, Jason Sugarman, Danny Thomas, Jay J. Shapiro, Marvin Wilson, Michel Kossak, Christine Talbot, Joe Martinez, Edward Dooner, Adriana Hernandez Jiminez, and Roseanne Lehman. To "Stuntman" Joe Sirko—thanks for your support. To Roy M. Medawar—thanks for being a friend. This book is in memory of William P. Griffin, who is gone but not forgotten.

Very special thanks go to my brother, David J. Somrack, for doing the heavy lifting and always encouraging me to pursue impossible dreams.

INTRODUCTION

When a dapper, young bank clerk from San Francisco named James J. Corbett dethroned the great bare-knuckle brawler John L. Sullivan on September 1892, the modern era of professional boxing was born. As the first champion crowned under the newly instituted Marquess of Queensberry Rules, Corbett's victory ushered in the golden age of boxing.

The California Gold Rush of 1849 brought thousands of men to the West Coast searching for buried treasure. Close behind the rush of miners were men of the squared circle offering entertainment and betting opportunities for mining camp workers. San Francisco was the first big city on the Pacific Coast to take an active interest in prizefighting, and by the 1890s the city's numerous sporting clubs established the Bay Area as the mecca of boxing.

Around 1885, former middleweight boxing champion of California Alec Greggains opened a boxing academy in the city called the San Francisco Athletic Club. Originally located on Shipley between Fifth and Sixth, the club was the Bay Area's main training center for young fighters until it was destroyed by the earthquake and fire of 1906.

When the Lewis Law legalized boxing matches only in members-only athletic clubs, San Francisco venues like the Yosemite Athletic Club, the California Athletic Club, and the Reliance Athletic Club in nearby Oakland sprang up to develop some of the finest amateur and professional talent in the country. But the fabled Olympic Athletic Club of San Francisco produced the greatest fighters of the era.

The Olympic Club, founded in the 1860s, produced more champions than any sporting club in the nation. The Olympic employed famed English boxing instructor Walter Watson, who brought it international recognition. Watson developed James J. Corbett into a world heavyweight champion. Although the Olympic was also destroyed in the 1906 quake, it was rebuilt within a year to continue its great tradition.

Many of the San Francisco champions were recognized by their press-created monikers like "Chrysanthemum" Joe Choynski, "The Little Champ" Abe Attell, and "The Nob Hill Terror" Monte Attell. Other native sons were immortalized for bringing world titles home to San Francisco, such as Jimmy Britt, Frankie Neil, and Willie Ritchie. Even adopted son Sam Berger, another Olympic Club alumnus, is best known for being the first Olympic heavyweight champion, winning the gold medal at the 1904 St. Louis Games. With so much talent originating in the city, San Francisco became known as "The Cradle of Fistic Stars."

The golden age was also a period of transition for boxing as it emerged from the crude, bare-knuckle brawls under the London Prize Ring Rules to a respectable art form under the Marquess of Queensberry Rules. The Queensberry Rules prescribed glove-fighting, three-minute rounds, the ten-count, and one-minute rests between rounds. Wrestling and hugging were barred.

Between 1890 and 1914, politically minded bureaucrats were continually revising laws that governed the sport. These politicians seeking votes at the polls and political patronage were often responsible for altering and amending laws, often to placate their constituency. These changes were made under the pretext of "cleaning-up" the sport, ridding it of crooked referees, bad judging, and betting scandals. Before the sport would gain national acceptance, it would endure numerous incarnations.

New Orleans became the first to pass a city ordinance in 1890 permitting gloved fights under Queensberry Rules but only if sponsored by members-only athletic clubs. In addition, referees were allowed to stop contests and award decisions. The athletic clubs of New Orleans also helped to systemize boxing in the United States by officially recognizing six distinct weight classifications. Six years later New York, along with California, legalized boxing under the Norton Law allowing 25-round gloved contests, with Nevada following suit in 1897.

The Norton Law was repealed in New York in 1900 after the Lewis Law went into effect (fights sanctioned by members-only athletic clubs). It changed again in 1911 with the Frawley Law, allowing 10-round, no-decision bouts (the 10-round limit applied to most states with the exception of California). Under the Frawley Law, bouts were essentially exhibitions, with no decisions or winners unless by knockout. Therefore, without a knockout, a title could not change hands and it was recorded in the record books as a "ND" or "no-decision."

For the purpose of settling bets during this "no-decision" period, predetermined newspapermen covering the fight from ringside would announce their unofficial winner in their news column the following day. These became known as "newspaper decisions." Corruption still flourished in the sport with managers and backers forcing decisions on writers, but it ended when the Frawley Law was repealed in 1917. It wasn't until May 24, 1920, when New York governor Al Smith signed the "Walker Boxing Bill" into law that New York became the first state to legalize boxing.

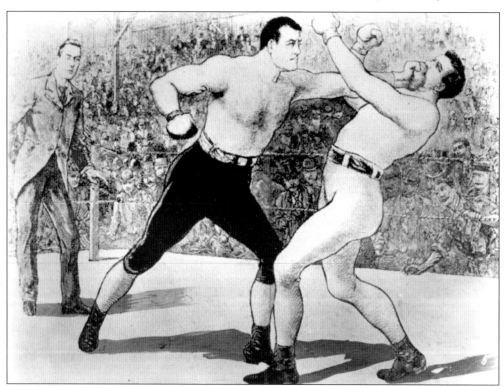

This illustration shows San Francisco's "Gentleman Jim" Corbett battling John L. Sullivan. Corbett connects with a left jab to the jaw of Sullivan on his way to the heavyweight crown in 1892.

Two new weight divisions were created in this era. In 1903, Chicago sportswriter Lou Houseman created the under 175-pound, light-heavyweight class for a boxer he managed. Houseman represented Jack Root, who was too big to fight at the middleweight classification and too small to be a heavyweight. Lastly, in 1910, the 112-pound flyweight division was born. Boxing now had eight weight divisions, known as the "original eight."

San Francisco venues like Woodward's Pavilion and Mechanics' Pavilion hosted many of the greatest boxing matches of the golden age. Local heroes like Alec Greggains, Jim Corbett, Abe and Monte Attell, Jimmy Britt, and Willie Ritchie all won or defended their world titles in these hallowed halls. Ring legends like Jim Jeffries, Bob Fitzsimmons, Stanley Ketchel, George Gardner, Dixie Kid, Joe Walcott, "Philadelphia" Jack O'Brien, Joe Gans, Peter Jackson, Terry McGovern, Tommy Burns, and Jack Johnson all fought in San Francisco.

Barbary Coast promoters would benefit greatly during the "no-decision" era when championship matches were driven west. Just south of San Francisco, in Colma, the state's leading promoter, Jim Coffroth, built the Mission Street Arena. Called "Sunny Jim" because of his good luck with the weather at his open-air shows, Coffroth allowed 45-round fights. The Mission Street Arena hosted ring legends such as Joe Gans, Stanley Ketchel, Battling Nelson, Tommy Burns, Ad Wolgast, Abe Attell, Jimmy Britt, Jack Johnson, Willie Ritchie, and Owen Moran. Thanks to the incredible talent of local San Francisco photographer Percy Dana, stunning images of these great athletes have been preserved on film. Many of Dana's classic photographs appear in this book.

The golden age of boxing ended in 1914 with the outbreak or World War I. (After 1914 boxing contests in California were limited to four rounds). Most world titles of the eight divisions would remain frozen until the war ended in 1918. However, by the time the 1920s began to roar, boxing would be legalized and accepted as a national pastime. Boxing in San Francisco begins with the colorful and charismatic "Gentleman Jim" Corbett.

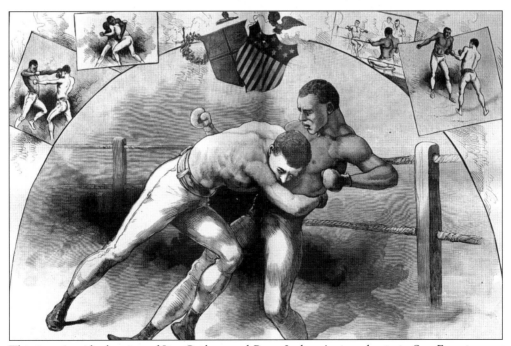

This is a ringside drawing of Jim Corbett and Peter Jackson's ring classic in San Francisco on May 21, 1890. John L. Sullivan drew the "color line" to avoid fighting Jackson, but Corbett agreed to meet "The Black Prince," and they fought to a bruising, 61-round draw.

One

JAMES J. CORBETT

"GENTLEMAN JIM"

When San Francisco's James J. Corbett ascended to the heavyweight throne, it marked a new era in the sport of prizefighting. Corbett defeated the great John L. Sullivan to become the first heavyweight champion crowned under the newly instituted Marquess of Queensberry Rules. The Queensberry Rules stipulated that fighters wear gloves, fight three-minute rounds, and be given a one-minute rest between rounds. With Corbett's scientific fighting method, along with new rule changes, the fight game was revolutionized.

The Corbett-Sullivan contest took place on September 7, 1892, at the famed Olympic Club in New Orleans. Boxing had been outlawed throughout the United Stated, but in 1890, New Orleans passed a city ordinance allowing contests as long as they were sponsored by a members-only athletic club and were fought under the Queensberry Rules. Sullivan had already reigned for a decade under the bare-knuckle London Rules.

John Lawrence Sullivan, nicknamed "The Boston Strong Boy," was born in the Boston suburb of Roxbury, Massachusetts, in 1858 to poor Irish immigrants. Sullivan rose from the streets of Boston to become a champion, a folk hero, and America's first sports idol. His swaggering, supremely confident, never-take-a-back-step approach to the fight game made Sullivan extremely popular throughout the country. Yet the well-groomed Jim Corbett considered Sullivan a boozing, brawling braggart who needed his comeuppance.

James J. Corbett was the antithesis of the rough and rowdy Sullivan. A stylish bank clerk from a middle-class family, Corbett had attended college and was considered a gentleman. "Gentleman Jim" learned to box at the respected Olympic Club in San Francisco under the tutelage of Englishman Walter Watson, who taught a modern, scientific method of fisticuffs.

Interest in a Sullivan-Corbett match-up reached a crescendo in 1891 when the press started publicly criticizing Sullivan for not defending his crown. Since his 75-round title defense against Patty Ryan in July of 1889, he had only engaged in exhibitions. Sullivan spent most of his time touring the country as an actor in a stage show called *Honest Hearts and Willing Hands*. Meanwhile, Corbett was busy defeating all of the top heavyweight contenders including Jake Kilrain, Joe Choynski, and Peter Jackson of Australia. With these victories under his belt, Corbett had become a legitimate contender for Sullivan's heavyweight crown.

Corbett was confident that he could beat the legendary "Strong Boy" after a sparring session they had in 1891. Sullivan, in town during a theatrical tour, agreed to spar an exhibition with Corbett for the capacity crowd. Oddly, Sullivan requested they spar in full evening attire, which they did. This spur-of-the-moment demonstration allowed Corbett to ascertain Sullivan's strengths and weaknesses as a pugilist. After the four-round exhibition, Corbett was convinced he had learned enough about Sullivan's fighting style to dethrone him.

In a newspaper article, Sullivan issued an open challenge to all "white contenders" in the world. The purse would be $25,000 with a side bet of $10,000. The winner would walk away with the heavyweight title and the $45,000. In order to make the fight, the challenger had to come up with the initial $10,000. The first man to accept the challenge and raise the seed money was James Corbett. He and his manager, the famous theatrical impresario William A. Brady, signed the contract.

With money in hand, the Sullivan-Corbett battle was set for September 7, 1892. Their fight was part of a boxing extravaganza promoters called the Carnival of Champions. It was held at the New Orleans Olympic Club in a specially built 10,000-seat arena that was wired with electricity. The weeklong event featured three separate championship bouts. On September 5, lightweight champion Jack McAuliffe retained his title with a Round-5 knockout of Billy Meyer. On September 6, featherweight champion George Dixon knocked out Jack Skelly to retain his crown.

With ticket prices for the main event scaling from $5 to $15 per seat, the 10,000-seat arena sold out, making this fight the largest live-gate boxing event up until that time. On heavyweight fight night, the 33-year-old Sullivan weighed 212 pounds and was a 4-1 favorite over the 26-year-old Corbett, who weighed in at 178 pounds.

Jack McAuliffe worked Sullivan's corner and Professor Mike Donovan was in Corbett's. Donovan proved to be a valuable asset due to the fact he had fought Sullivan twice himself and was able offer Corbett pointers throughout the bout.

The out-of-shape Sullivan spent the early rounds charging his challenger in a futile attempt to land his famous haymaker, but Corbett skillfully sidestepped the champion's advances and countered with punishing jabs. In Round 3, Corbett broke Sullivan's nose with one of his perfectly timed counter-punches, causing blood to gush from it throughout the fight. In Round 8, Donovan instructed Corbett to concentrate on Sullivan's body, which was vulnerable to offensive attack. Corbett's speed and agility enabled him to wear down the champion, and by Round 14 the fight was his.

In Round 21, Sullivan fell backwards into his corner, completely spent and no longer able to defend himself. Corbett rushed the champion and landed a continuous series of punches until Sullivan collapsed to his knees. Sullivan managed to rise again but was beaten back to his knees and fell face forward onto his stomach. The fight was over and a new era in boxing had begun.

Sullivan was knocked out only once during his long career—by Gentleman Jim Corbett in 1892. When the Corbett fight was over, Sullivan staggered to his feet and went to the ring ropes and addressed the crowd. "The Old Man went up against it just once too often," said Sullivan. "He was beaten—but by an American."

James John Corbett was born on September 1, 1866, in San Francisco. He was one of 11 children born to Patrick J. Corbett and Kate McDonald, Irish immigrants who came to America fleeing the famine that crippled Ireland for over a decade.

After graduating from high school, James worked briefly on the waterfront before taking a job as a bank clerk where his mathematical abilities served him well. Shortly thereafter, he joined the Olympic Athletic Club to play baseball and meet "important people." The club's boxing instructor was a 55-year-old Englishman named Walter Watson. Professor Watson convinced Corbett to forego baseball and turn his attention to the manly art. The rest is history.

Corbett proved to be a "quick study" and soon entered amateur competitions, compiling an impressive win-record against the top amateurs in the city. At 6-feet, 1-inch in height, he was actually a tall light-heavyweight who rarely weighed over 175 pounds, yet his natural ability and quick reflexes made bigger men look foolish. Corbett's nemesis in the ring was a local kid named Joe Choynski. With Choynski being Jewish and Corbett Irish, they developed a natural rivalry. Their first contest as professionals was in 1889 in a stable loft in Sausalito, California. They fought four bruising rounds before the local sheriff stopped the illegal contest. With nothing resolved, they agreed to meet again.

Their second bout took place on a barge anchored off Benicia in San Francisco Bay. Fighting under the boiling sun, they went toe-to-toe until Choynski collapsed from exhaustion in Round 27. They met a third time, one month later in San Francisco, with Corbett winning again in four rounds. Although he never won a world title, Choynski was a formidable opponent and one of the greatest fighters of any era.

During Corbett's tenure as an auditor for city hall, he received a message from the sports editor at the *San Francisco Chronicle*. The editor received a telegram from top contender Jake Kilrain offering to fight Corbett for a purse of $2,500, with $2,000 going to the winner and the remainder to the loser to pay for transportation to and from New Orleans. Kilrain had gained international fame for battling Sullivan for 75 rounds. Corbett accepted the challenge, but the bout proved to be one of Corbett's easiest fights. After six rounds of a one-sided contest, Corbett was declared the winner.

The greatest challenge of Corbett's young career came at the hands of the 6-foot, 200-pound Peter Jackson, a black fighter from Australia via the West Indies, whom Sullivan refused to fight because of the color of his skin. Known as "The Black Prince," Jackson was believed by many to be the best fighter in the world. Although Corbett's own handlers tried to dissuade him from accepting a challenge from the dangerous Jackson, Corbett insisted. On May 21, 1890, they met at San Francisco's California Athletic Club.

The first 30 rounds of the Corbett-Jackson contest were an amazing display of ring generalship and clever defensive maneuvers. With both fighters in superb physical condition, the fight dragged on into rounds 40 and 50 with neither man able to score the finishing blow. After 61 rounds, both men were too exhausted to continue. The referee stopped the bout by shouting, "I declare this fight a no-contest. All bets are off!" Corbett's draw with Jackson made him the number one contender for Sullivan's crown. The following year, Corbett would realize his dream.

As champion, Corbett toured the country giving exhibitions to packed houses and earning a considerable fortune. On January 25, 1894, he had the first defense of his title in Jacksonville, Florida, against England's Charlie Mitchell. Corbett employed all of his scientific ring skills against the brawling Mitchell and battered the challenger into submission within three. After the Mitchell victory, Corbett went back on the road giving boxing exhibitions and acting in the stage play *Gentleman Jack*.

By 1897, middleweight champion Robert Fitzsimmons was on the horizon, campaigning as a heavyweight. Desperate for a title shot, Fitzsimmons began challenging Corbett in the press. Gentleman Jim eventually relented and agreed to defend his crown against the Cornishman in Carson City, Nevada. For a purse of $15,000 and a $2,500 side bet, they met on St. Patrick's Day 1897.

Called "Ruby Robert" because of his freckled complexion and auburn hair, Fitzsimmons had an unusual body for a boxer. He had the massively muscled upper body of a blacksmith, which he was, balanced atop skinny, spindly legs that took up two-thirds of his body. In his prime he weighed between 150 and 170 pounds, 30 to 40 pounds lighter than most of the heavyweights he was beating at the time.

Corbett dominated the early rounds of the Fitzsimmons bout and even dropped him with a perfectly timed left hook to the chin in Round 6. Fitzsimmons was up at the count of nine, but Corbett continued to outmaneuver and jab the challenger, making his chances of winning grow bleaker. Despite his lackluster performance, Fitzsimmons tried desperately to score to Corbett's body with looping lefts and rights. Corbett remained in control, but as the fight wore on his defensive tactics began to lose their fluidity.

In Round 14, Fitzsimmons feinted with his right and stepped forward and unloaded a left, full force into Corbett's midsection, directly under the heart. Corbett slumped forward, his wind gone. As the champion sank to his knees, Fitzsimmons planted another power punch behind Corbett's left ear for good measure, but the damage had been done. Corbett fell to the canvas paralyzed, unable to rise. He tried crawling toward the ring ropes but all he could do was lie

there and watch Fitzsimmons be declared the winner and the new heavyweight champion. The timekeeper was famed lawman Bat Masterson.

Corbett recalled the loss to Fitzsimmons in his autobiography *The Roar of the Crowd*: "I was conscience of everything . . . the silence of the crowd, the agony on the faces of my seconds, the waiting Fitzsimmons, but my body was like that of a man stricken with paralysis."

Bob Davis, a journalist for the *New York Journal*, overheard two San Francisco physicians describing the blow as a punch to the solar plexus. In Davis's dispatch the following day, he introduced the "solar plexus punch" into the lexicon of boxing. Interviewed after the fight, Fitzsimmons referred to the blow as "a bloomin' good belly clout."

Corbett spent the following two years trying to persuade his rival to give him a rematch, but Fitzsimmons ignored him. It wasn't until Jim Jeffries dethroned Ruby Robert that Corbett was given the opportunity to regain his heavyweight title.

In 1900, Corbett challenged Jeffries for his heavyweight crown. The contest was scheduled for 25 rounds, and by all accounts Gentleman Jim won the first 22. He jabbed and moved with style and grace resembling the Corbett of old. Suddenly in Round 23, Jeffries landed a bomb on Corbett's chin, ending his chance of becoming the first man to regain the heavyweight championship.

After the fight and in semi-retirement, Corbett resumed his acting career and gave boxing exhibitions across the country. He opened a saloon in New York City called Jim Corbett's that attracted New York's social elite. But Corbett felt unfulfilled and wanted to retire as heavyweight champion. He reached out to Jeffries for a rematch.

In 1903, with no serious competition on the horizon for Jim Jeffries, he offered Corbett a second chance to regain his title. The Corbett-Jeffries rematch at Mechanics' Pavilion was a one-sided affair with the 36-year-old Corbett being dropped in Rounds 3 and 5, and finally knocked out in Round 10. It was Gentleman Jim Corbett's last professional fight. He recorded 25 pro bouts, with 14 wins (7 knockouts), 4 losses, and 4 draws.

In retirement, Corbett had a successful stage career and wrote for various sporting magazines and newspapers. Gentleman Jim Corbett remained a public figure and celebrity until his death in 1933. He was elected into the International Boxing Hall of Fame in 1990.

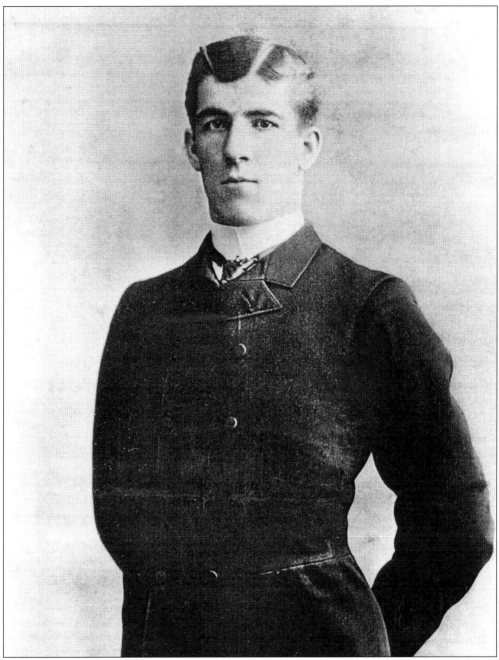

This is an image of James J. Corbett at 18 years old. (Courtesy of Gary Phillips.)

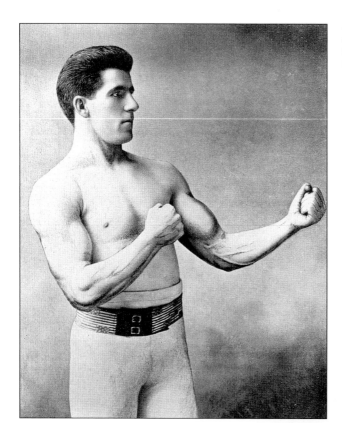

James J. Corbett shows off a classic boxing stance. (Courtesy of Todd Ryan.)

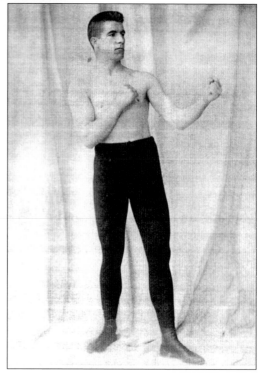

In this *c.* 1891 photo, Jim Corbett strikes a fighting pose as the number-one contender for John L. Sullivan's heavyweight crown.

John L. Sullivan, "The Boston Strongboy," photographed at the height of his career in the 1880s, was the last bare-knuckle heavyweight champion of the world.

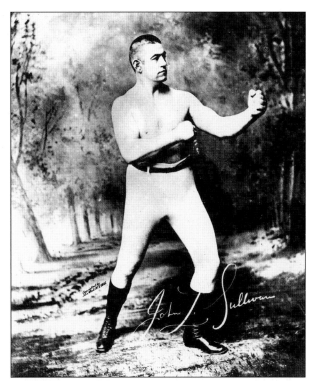

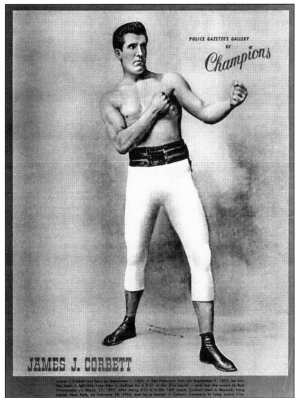

Born in 1866 in San Francisco, "Gentleman Jim" Corbett set his sights on succeeding John L. Sullivan. An astute observer, Corbett's outstanding footwork and defensive skill introduced ring science to the fight game. He became the first Marquess of Queensberry Rules champion. This image depicts Corbett at the time of his historic 61-round fight with Peter Jackson. Even though the contest ended in a draw, the bout made Corbett a leading contender for John L. Sullivan's heavyweight crown. (Courtesy of J.J. Johnston.)

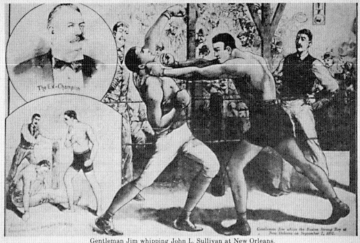

CORBETT NOW IS CHAMPION

SULLIVAN MEETS HIS MATCH AT NEW-ORLEANS.

THE CALIFORNIAN KEPT AWAY FROM
THE BIG FELLOW'S BLOWS, AND
FINALLY FORCED THE FIGHTING—
THE BOSTON PUGILIST KNOCKED OUT
IN THE TWENTY-FIRST ROUND.

Gentleman Jim whipping John L. Sullivan at New Orleans.

The original sports page headlines of the *New York Times* from the morning of September 8, 1892, following Corbett's victory over Sullivan, gave a round-by-round description of the big event.

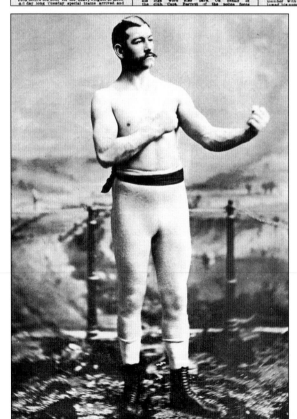

In this 1882 photo, John L. Sullivan stands ready as the 1882 heavyweight champion of America—under London prize ring rules.

18

The historic Sullivan-Corbett heavyweight championship bout was held at the Olympic Club in New Orleans on September 7, 1892. Pictured here is James J. Corbett in an advertising card, along with a cabinet photo card of John L. Sullivan. (Courtesy of Bustout Productions.)

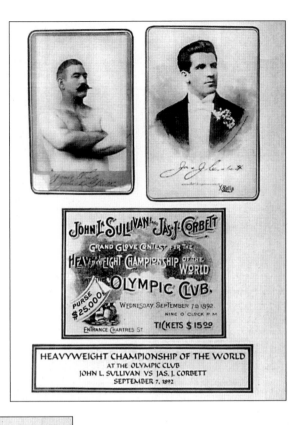

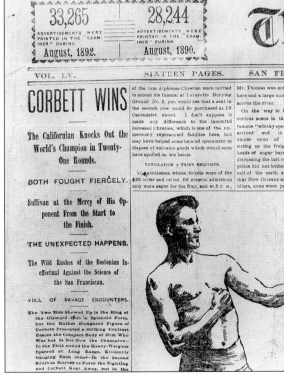

An August 1892 *San Francisco Chronicle* article announces that Californian James Corbett wins the world championship.

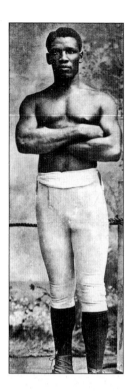

Born in 1861 in the West Indies, Peter Jackson relocated to Australia where he began his boxing career in 1882. Despite his great physical skills, he was never offered a chance to win the title. Ignored by Sullivan because he was black, Jackson is considered by boxing experts as one of the greatest fighters of all time. Beat up and broken, Jackson died in a charity ward in 1901 at the age of 40. (Courtesy of Bustout Productions.)

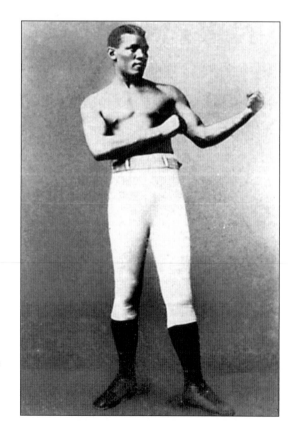

In his fighting prime, "The Black Prince" stood 6-feet, 1-inches tall and weighed 200 pounds. Here Jackson displays his physique in a fighting pose.

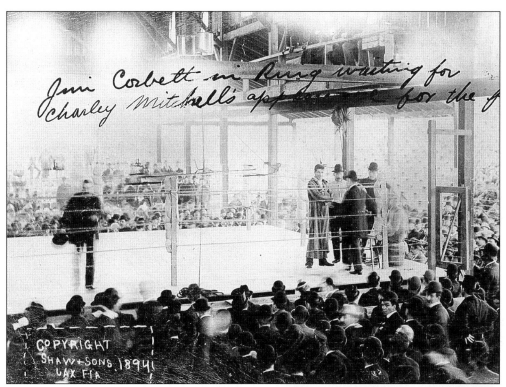

Jim Corbett in ring waiting for Charley Mitchell's appearance for the f...

COPYRIGHT
SHAW+SONS 1894
UAX FIA

Corbett is seen at center ring waiting for England's Charley Mitchell to appear. This bout, held on January 25, 1894, at the Duval Athletic Club in Jacksonville, Florida, was Corbett's first defense of his heavyweight crown. Corbett had been touring the country in the stage play *Gentleman Jack* when he was insulted in the press by Mitchell, who demanded a showdown. Corbett, with his vastly superior ring skills, ended the feud by knocking Mitchell out in three rounds.

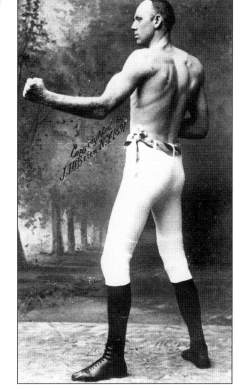

"Ruby Robert" Fitzsimmons, boxing's first three-division winner, displays the powerful upper torso he developed during his days as a blacksmith. His courage in the ring, willingness to take punishment, and remarkable recuperative powers made him one of the all-time greats.

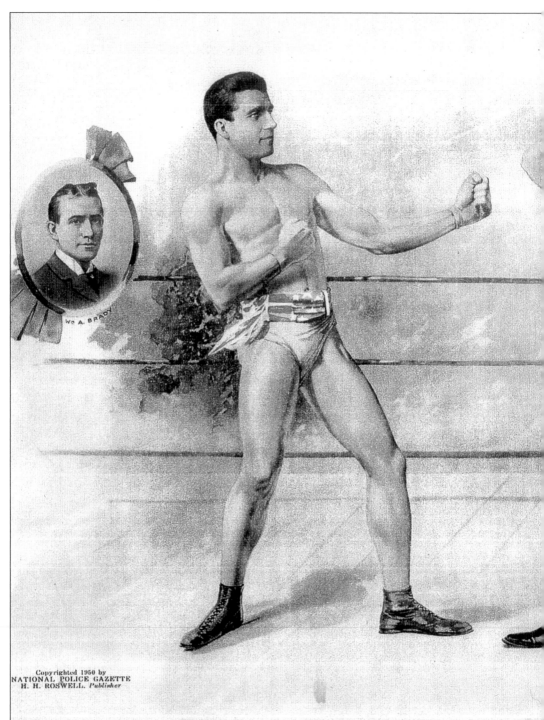

WM A. BRADY

JAMES J. CORBETT AND P

AS THEY WILL APPEAR

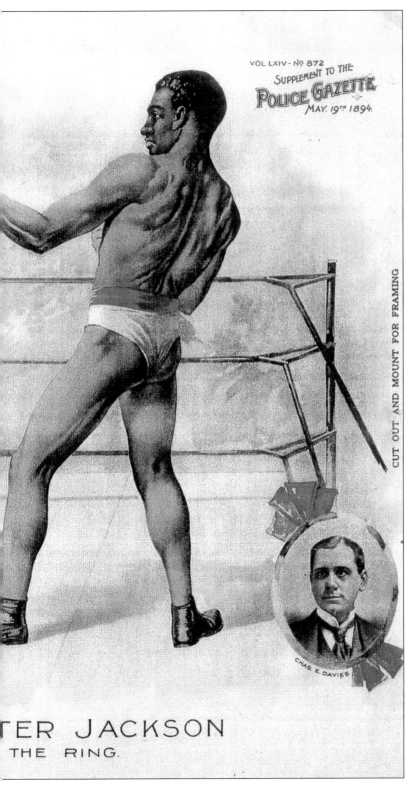

VOL LXIV - Nº 872
SUPPLEMENT TO THE
POLICE GAZETTE
MAY. 19TH 1894.

CUT OUT AND MOUNT FOR FRAMING

CHAS. E. DAVIES

TER JACKSON
THE RING.

This illustration shows Jim Corbett and Peter Jackson squaring off in their 1891 battle. In the upper left inset is Corbett's manager, San Francisco native William Brady, who guided the Barbary Coast fighter to the heavyweight championship. In the lower inset is Charles "Parson" Davies, Jackson's mentor. The Corbett-Jackson fight was declared a "no-contest" after 61 rounds. (Courtesy of J.J. Johnston.)

This is how Jim Corbett appeared during his reign as world heavyweight champion. Considered the father of modern boxing, he is credited with bringing science to the manly art of fisticuffs.

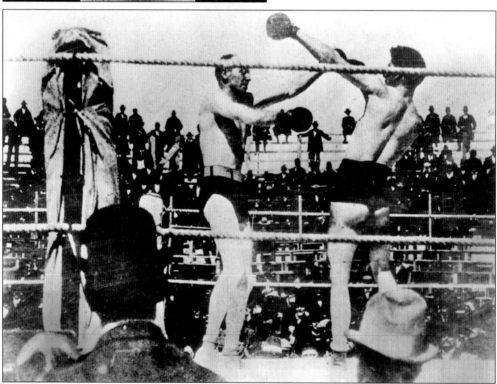

This image shows Jim Corbett and Robert Fitzsimmons meeting for the world heavyweight title. Their bout was the first championship fight to be recorded on film. After five years as champion, Corbett was favored in this title defense against Fitzsimmons on St. Patrick's Day 1897. Early in Round 14, the hard-hitting Fitzsimmons sidestepped one of Corbett's blows, feinted a right to Corbett's head, then stepped forward and delivered a paralyzing straight left to Corbett's stomach, following up with a right to his head. Corbett went down for the count. The "solar plexus punch" was born and the world had a new heavyweight champion.

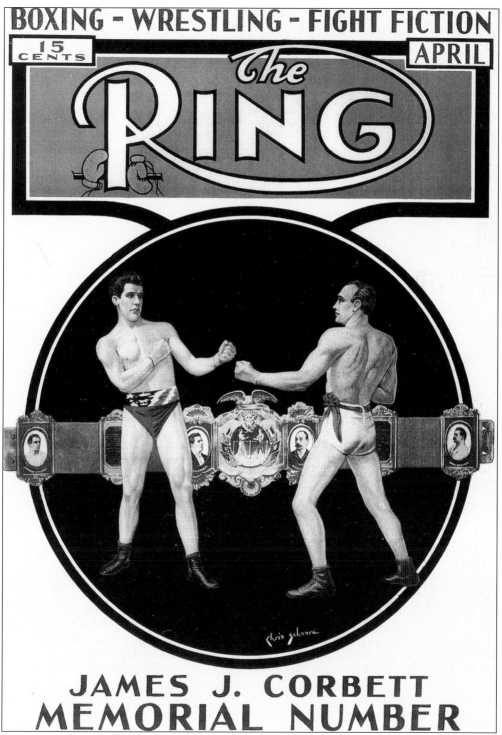

This image shows the cover of *The Ring* magazine memorial issue for James J. Corbett. (Courtesy of J.J. Johnston.)

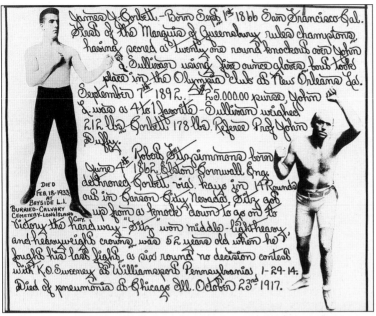

James J. Corbett.—Born Sep. 1st 1866 San Francisco Cal. First of the Marquis of Queensbury rules champions, having scored a twenty one round knockout over John L. Sullivan using five ounce gloves but took place in the Olympia Club at New Orleans La. September 7th 1892. $25,000.00 purse, John L. was a 4 to 1 favorite—Sullivan weighed 212 lbs. Corbett 178 lbs. Referee Prof. John Duffy.

Robert Fitzsimmons born June 4th 1862. Elston Cornwall Eng. dethroned Corbett via. kayo in 14 Rounds out in Carson City Nevada, Fitz got up from a knock down to go on to victory the hard way—Fitz won middle—light heavy, and heavyweight crowns, was 52 years old when he fought his last fight, a six round no decision contest with K.O. Sweeney at Williamsport Pennsylvania, 1-29-14. Died of pneumonia at Chicago Ill. October 23rd 1917.

DIED FEB. 18-1933. AT BAYSIDE L.I. BURRIED—CALVARY CEMETERY—LONG ISLAND N.Y. City.

Shown here is a biography sketch of both James Corbett and Robert Fitzsimmons.

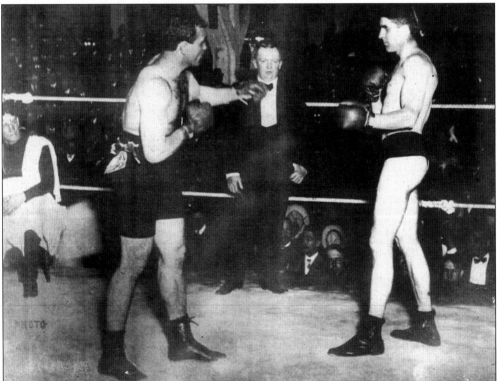

Gentleman Jim squares off with Jim Jeffries at San Francisco's Mechanics' Pavilion in this photo. This August 14, 1903 fight would be the last professional fight of Corbett's career. Failing in his first attempt to wrest the heavyweight crown from Jeffries three years before, Corbett made one final try to become the first man to regain the crown. Jeffries proved too strong for the 36-year-old Corbett and won by knockout in the Round 10. (Courtesy of J.J. Johnston.)

In this photo, Jim Corbett strikes a theatrical pose he would use on Broadway after his retirement from the ring. His style, manners, and grace gave boxing class and respectability. After boxing, the former champion enjoyed a successful stage career appearing in New York productions like *The Navel Cadet* and George Bernard Shaw's *Cashel Byron's Profession*.

Two

JOE CHOYNSKI

"THE CALIFORNIA TERROR"

Joe Choynski is considered by boxing experts as one of the greatest uncrowned boxing champions in the long and celebrated history of the heavyweight division. He fought in San Francisco when the Bay Area was considered the epicenter of the sport, and as a Jewish pugilist, he was revered as a hero to his people.

Joseph Bartlett Choynski was born in San Francisco on November 8, 1868, in the same neighborhood as James J. Corbett. He hailed from a distinguished California pioneer family. His mother, Harriet, was a writer and his father, Isodore Nathan Choynski, originally from Poland, grew up in Connecticut. Isodore earned his teaching certificate at Yale University as one of the school's first Jewish alumni.

"Chrysanthemum" Joe Choynski, so named because of his long locks of blond hair, was known for tremendous punching power as well as his scientific approach to boxing. He began his amateur career in 1884 and, within three years, he was heavyweight champion of the Pacific Coast.

Considered small for a heavyweight, Choynski stood 5-feet, 10-inches tall with a body weight that fluctuated between 160 to 170 pounds. Throughout his brilliant career "Little Joe" challenged many fighters who at one time or another held world boxing titles. He faced off against James Corbett, Bob Fitzsimmons, "Philadelphia" Jack O'Brien, Marvin Hart, Jack Johnson, Jim Jeffries, Kid McCoy, and Joe Walcott, to name a few.

A rebellious kid, Choynski dropped out of high school at 16 years of age. Frequently involved in scuffles with dockworkers along the Barbary Coast, Joe was persuaded by friends to join the Golden Gate Athletic Club to channel his aggressions into boxing. From the start he showed a natural agility augmented by the great physical strength he developed through his twin trades of candy puller and blacksmith. Beginning in local competitions in and around San Francisco, he immediately built a solid reputation as a tough and fearless fighter.

After a successful amateur career, Choynski had his first professional fight on November 14, 1888, 6 days prior to his 20th birthday. Record books recorded a Round-6 knockout victory over George Bush. In his third professional fight, a win over George Glover, Choynski returned home with a $1,000 first prize and gained acceptance from his conservative, intellectual parents who had earlier tried to dissuade him from boxing.

During this time, Joe's brother Herbert worked at a bank in the city with a man named Frank Corbett, brother of James. Before long they were challenging their brothers in a competition to see who ruled the district. It was a natural competition between the two—Choynski from the Golden Gate Club and Corbett of the Olympic Club.

The first Choynski-Corbett bout took place on May 30, 1889, in rural Fairfax, California. Although evenly matched, Corbett was quicker on the draw and was able to score with jabs. By

Round 4, Corbett was in complete control of the fight when the sheriffs moved in and halted the contest. Since it ended without a decision, the pair agreed to a second match four weeks later.

Choynski-Corbett II, known as the "Barge Fight," was recorded in boxing history as one of the greatest ring battles of all time. It was fought on the June 6 at Benicia, California, on a barge moored in San Francisco Bay. Over 200 spectators witnessed this classic bout. The fight was described by boxing historian Frank Menke as "one of the epic battles of pugilism. For [its] duration and savagery, it perhaps never had its equal."

Choynski weighed 172 pounds to Corbett's 180. The match was fought in the sweltering afternoon heat. Corbett, two years older, had more ring experience than his neighborhood foe. "Nonpareil" Jack Dempsey, the middleweight champion, worked Joe's corner. When Dempsey realized that Corbett had dislocated a thumb in a pervious fight he "accidentally" lost Choynski's gloves. He hoped they would agree to a bare-knuckle brawl that would give Choynski an advantage. But the ploy didn't work. Corbett refused to fight without his five-ounce mufflers.

With no regulation gloves available, Corbett agreed to fight if Choynski wore a pair of driving gloves a spectator had offered. Corbett soon discovered that driving gloves have three heavy seams running down the black side. Each time Choynski made contact, the punch would leave painful, raised welts on Corbett's skin.

In Round 14, Corbett re-broke his thumb. The referee tried to stop the contest but both fighters refused to quit. By Round 25, Choynski was bleeding profusely and Corbett had suffered two broken hands and deep gashes over both eyes. In Round 27, with both fighters completely exhausted, Corbett summoned all of his remaining strength and landed a perfectly timed left hook, a punch he's credited with introducing into boxing. Landing on the point of Choynski's chin, Joe went down for the count. Corbett, barely able to stand, was declared the winner.

Choynski and Corbett fought for a third time six weeks later. Not fully healed from their first two meetings, they met on July 15. After four close rounds, Corbett was declared the winner. Following this third bout with Corbett, Choynski needed six months to fully recover before resuming his career.

In 1890, Choynski sailed for Australia to open the boundaries of his pugilistic career. In his first fight "down under," he faced off against Jim "Jawbreaker" Fogerty for a guaranteed purse of $2,200. Despite his moniker, Fogerty was the one who ended the bout with a broken jaw in Round 8. The following year Choynski had two fights with Australian champion Joe Goddard. Due to the incredible pace, both bouts ended after four rounds with neither man able to continue due to exhaustion.

Choynski returned to California in December 1891 with $28,000 he had earned in prize money. Within weeks he sparred a three-round exhibition with John L. Sullivan and knocked out Billy Woods in a 34-round contest.

On June 18, 1894, "The California Terror" took on future heavyweight champion Bob Fitzsimmons in Boston. He dropped Fitzsimmons with a left to the chin in Round 4, but Ruby Robert was back on his feet by the count of eight. In the next round, Fitzsimmons landed a solid right that dropped Choynski for a four-count, but as soon as Joe was able to rise, police intervened and the fight was halted and ruled a draw.

In San Francisco on November 30, 1897, Choynski took on another future heavyweight champion, James J. Jeffries. Jeffries measured in at 6-feet, 3-inches tall and weighed over 220 pounds, which gave him a 5-inch and 50-pound weight advantage over Choynski. This bout marked only the seventh professional fight for Jeffries, who was undefeated. In an action-packed Round 5, Jeffries was able to land a hard left on Choynski's jaw, dropping him for an eight-count. After 20 rounds, the fight was ruled a draw.

At the end of his career, Jeffries admitted that Choynski hit him with the hardest shot of his career. He said he was hit with such force that the punch broke his nose and drove his teeth through his upper lip.

In a non-title match up, Choynski met welterweight champion Kid McCoy. The January 12, 1900, bout nearly created a riot at New York's Broadway Athletic Club. Choynski had McCoy

knocked out in Round 2, but the judge sounded the bell a full minute early, thereby saving McCoy from a knockout loss and allowing him two minutes to recuperate between rounds. Then, in Round 4, Choynski was floored and the fight was immediately stopped. The fix was in. The controversial outcome of this fight resulted in America adopting a scoring system of two judges and a referee.

Choynski was scheduled for a rematch with McCoy in February 1900, but Joe Walcott, "The Barbados Demon," was brought in as a last minute replacement. The bout resulted in a one-sided affair with Choynski on the receiving end of a terrible beating. At 5-feet, 1-inches tall and 145 pounds, Walcott was a 5-1 underdog before the fight. Surprisingly, Choynski was knocked out in the Round 7. It was one of the few times in Choynski's career that he lost a match to a smaller man. Choynski later admitted that he had been recuperating from a rib injury sustained in training a few weeks earlier. As he guarded his injury throughout the fight, he left himself vulnerable to the hard-punching Walcott.

In 1901, Choynski arrived in Galveston, Texas, on an exhibition tour. A young African-American heavyweight, a local favorite, was offering $200 to any man who could last four rounds in the ring with him. The fighter was Jack Johnson, who had been a professional boxer for five years but had only engaged in 11 contests. At that time, mixed-race matches were outlawed in Texas so the local promoter billed the fight as an exhibition.

The ten-round contest was even for the first two, but in Round 3, Choynski landed a left hook that put the "Galveston Giant" to sleep. It was the only time in Johnson's career that he was ever stopped other than his last fight against Jess Willard at the age of 36. As soon as Johnson fell, the Texas Rangers climbed into the ring and immediately arrested both men. Choynski and Johnson were jailed for 28 days. Johnson stated later that the month he spent in a cell with Choynski dramatically improved his boxing skills. Choynski had taught him the nuances of defense.

"The California Terror" fought for another three years. He knocked out Ireland's Peter Maher in two rounds and suffered two knockout losses to Kid Carter in 1902 and 1904, and one to Nick Burley in 1903. Then on November 24, 1904, after fighting Jack Williams in Philadelphia to a six-round no-decision, the 36-year-old Choynski retired from the prize ring. Choynski's professional record was 50-14-6, with 25 knockouts, 8 no-decisions, and 1 no-contest.

In retirement, Choynski became a popular stage actor. He toured the country in Parson Davies production of *Uncle Tom's Cabin* with boxing great Peter Jackson playing opposite him. From 1912 to 1922, Choynski was the boxing and athletic instructor for the Pittsburg Athletic Club. Afterward he became a licensed chiropractor. Eventually he moved to Chicago and sold insurance and even served as story consultant and technical advisor on the Hollywood film *Gentleman Jim* about his boyhood adversary Jim Corbett.

Chrysanthemum Joe Choynski was inducted into the Ring Hall of Fame in 1960 and the International Boxing Hall of Fame in 1998. Joe Choynski passed away in Cincinnati, Ohio, on January 24, 1943. He was 74 years old.

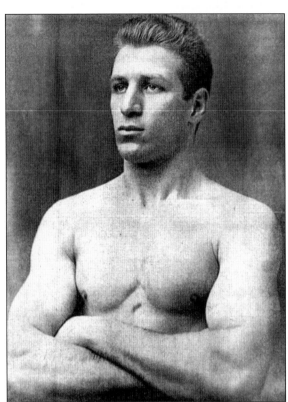

"Chrysanthemum" Joe Choynski posed for the camera in 1886.

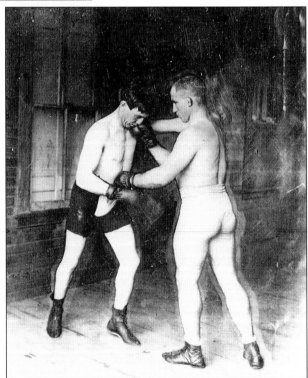

"Sailor" Tom Sharkey spars with featherweight and lightweight champ Frank Erne. Sharkey's San Francisco bout with Joe Choynski on March 11, 1998, ended in a draw. Choynski had three classic battles with Sharkey.

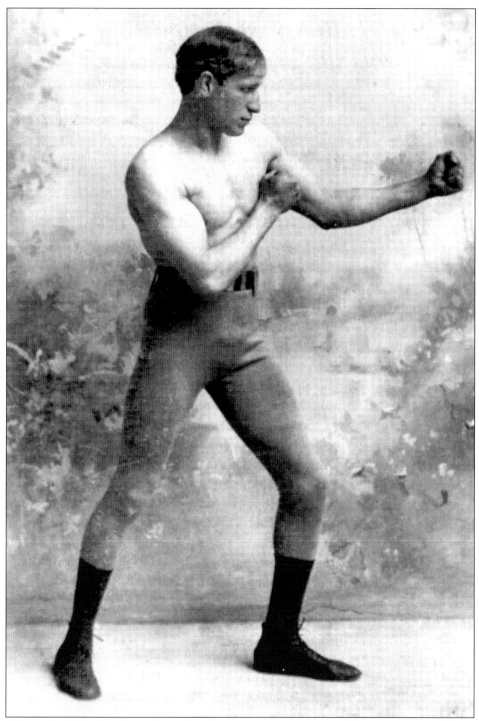

Joe Choynski, "The California Terror," is shown here at the height of his fistic prowess. Though never a titleholder himself, San Francisco's Chrysanthemum Joe fought the best fighters of the golden era and is considered one of the premiere heavyweight contenders in boxing history. At only 170 pounds, Choynski fought three epic wars with his crosstown rival Jim Corbett.

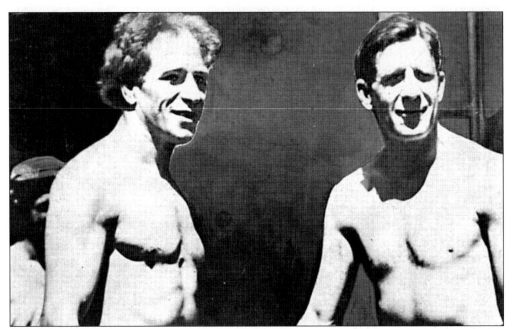

Joe Choynski (left) and Jim Corbett had three brutal ring battles early in their boxing careers. It wasn't until they both retired from the fight game that they reconciled their differences and became pals.

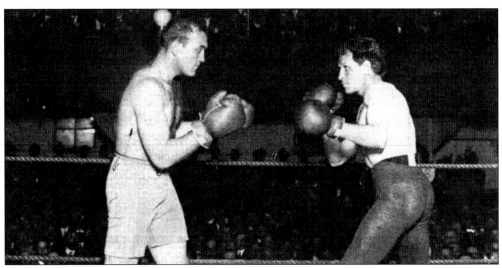

Joe Choynski (right) puts on a sparring exhibition with James J. Jeffries at San Francisco's Dreamland Rink on June 9, 1910.

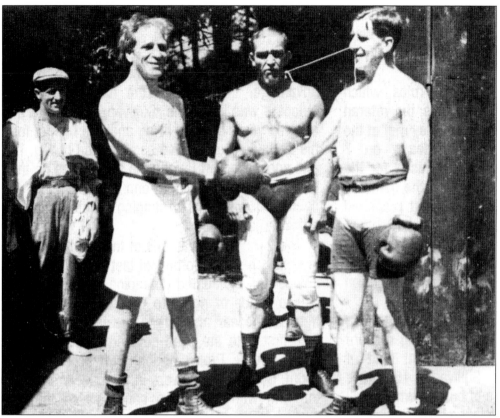

This 1910 photo shows ring legends Choynski and
Corbett ending their long-standing feud to assist pal
James Jeffries (center) in training for his bout with
Jack Johnson in Reno, Nevada.

Joe Choynski shows a fighting pose, c. 1895.

Three

ABE ATTELL

"THE LITTLE CHAMP"

Legendary fight promoter Tex Rickard, who made heavyweight champion Jack Dempsey a millionaire in the Roaring Twenties, once said, "The greatest fighter of any weight and of any class, in my opinion, was Abe Attell. He had remarkable stamina and courage, hands and feet that moved so fast they were impossible to follow and he possessed flawless coordination." At 5-feet, 4-inches tall and 122 pounds, Attell was known as the "The Little Champ."

Actually, Rickard's assessment of San Francisco's Abe Attell may have been an understatement. As one of the longest-reigning featherweight champions in boxing history, he challenged and defeated most of the great fighters of his era in several weight divisions. Outside of the ring, Abe Attell was a colorful character and notorious gambler. His supreme confidence in his ring abilities allowed him to often wager on his own fights.

Attell's title reign coincided with the no-decision era of boxing when most states in America prohibited point verdicts and a champion could only lose his title if he was beaten inside the distance of the contest. Attell used this no-decision ruling to claim the featherweight title from 1901 to 1912.

Abraham Washington Attell was born in San Francisco on February 22, 1884. He was 1 of 19 children born to Mark and Annie Attell, Jews who had emigrated from Russia. Abe grew up in a predominately Irish neighborhood known as "South of the Slot," (the slot was the trolley cable line on Market Street). Mark Attell owned a jewelry store at Third and Folsom Streets, and the family maintained a small residence behind the store.

As a Jew growing up in an Irish neighborhood, Abe learned to fight on the streets. When Abe was 13, his father abandoned the family and Abe took a job selling newspapers to offer support. His turf happened to be the corner of Eighth and Market Streets where the famed Mechanics' Pavilion once stood. In 1897 he witnessed the Solly Smith–George Dixon fight there, and it had a dramatic impact on his life. He dreamed of becoming a champion. After several years of training under the guidance of boxing master Alec Greggains, Attell turned professional.

Abe's first pro fight took place on August 19, 1900, against a local bully named Kid Lennett. Attell's second-round knockout of Lennett proved to the 16-year-old that he made the right decision. In his first year as a pro, Attell engaged in 16 bouts, winning 15 by knockout. The following year he relocated to Denver, Colorado, in search of keener competition and bigger paydays. In Denver, Abe continued his winning ways and even fought two draws with his boyhood idol and the first recognized featherweight champion of the modern era, George Dixon. Studying the crafty styles of Dixon and James Corbett, Attell mastered the techniques of slipping, feinting, and sidestepping punches. After realizing he couldn't knock out every

opponent he faced, Abe adopted a "fancy dan" style and grace to his overwhelming offensive arsenal. He knew the key to longevity in the fight game was ring savvy and finesse.

In St. Louis on October 28, 1901, 17-year-old Attell won his rubber match over fading legend George Dixon. That same year, Young Corbett II knocked out the hard-punching "Terrible Terry" McGovern to capture the featherweight crown. When Corbett and McGovern were unable to stay within the featherweight limit of 122 pounds, they vacated the division. Based on Attell's previous win over George Dixon, Attell claimed the title.

After the Little Champ defeated top contender Johnny Reagan in St. Louis in 1903 and Harry Forbes the following year, he was universally recognized as the world featherweight champion. Always confident in the ring and a gambler at heart, Attell bet his entire $5,000 purse on a Round 5 stoppage of Forbes. With time running out in Round 5, Abe turned on the gas and knocked out Forbes to claim the money and the title.

Another claimant to the featherweight crown at the time was "Brooklyn" Tommy Sullivan. To settle their dispute the two fighters met on the October 13, 1904. Although Abe was knocked out in Round 5, he claimed that Sullivan was over the 122-pound limit. The press agreed with Attell and he retained his claim to the crown. Always active, Abe put the title on the line three times in 1906 and again in 1907.

On New Year's Day in 1908, Abe defended his crown against England's Owen Moran. In one of the most thrilling fights of the golden era, Abe kept the championship by drawing with Moran over 25 rounds. An anti-Semite, Owen uttered "dirty Jew" insults throughout the fight, which enraged Attell. The two combatants resorted to every trick in the book, including wrestling, strangulation, and even biting. During a clinch as Owens was trying to strangle Attell, Abe bit off a chunk of Owens's nose. It was reported that when Owens complained to referee Jim Jeffries by asking for a disqualification, Jefferies looked Owens square in the eye and uttered, "Bite him back!"

Attell claimed that the toughest opponent of his career was lightweight king "Battling" Nelson. Their non-title encounter was held in San Francisco on March 31, 1908. Outweighed by almost 20 pounds, Attell employed all of his ring savvy and punching power and was able to dictate the action throughout the fight. The quickness of Attell's stiff jabs left Nelson's face battered and beaten and almost unrecognizable by the end of the fight. Surprisingly, referee Eddie Smith called the fight a draw, which caused a riot in the arena. As chairs and bottles were being hurtled into the ring, Smith was ushered out of the arena under police protection.

On April 30, 1908, Attell put his crown on the line once again against Tommy Sullivan in San Francisco. Sullivan was knocked out in Round 4 and Attell finally received worldwide recognition as the undisputed world featherweight champion.

In 1909, "The Little Hebrew" took on another top lightweight, England's Jim Driscoll. They fought a 10-round no-decision contest that Nat Fleischer, founder of *The Ring* magazine, described as "one of the best exhibitions of ring science ever seen in New York." Fortunately for Attell, it was ruled a no-decision contest despite the overall consensus that Driscoll had won the bout.

Abe Attell's long championship reign finally came to an end on his 28th birthday in 1912, when he lost his title to a man he'd beaten two years earlier, Clevelander Johnny Kilbane. The fight took place in Vernon, California, with Kilbane winning a decision over 20 rounds. The $15,000 Abe received as consolation was the largest purse of his career.

After a brief hiatus from the ring, Abe returned to fight former two-time Olympic gold medallist Ollie Kirk. In their first meeting, Abe quit after Round 6 and Kirk was awarded a knockout win. In their rematch three months later Abe avenged the loss with a Round-3 knockout. After winning a six-rounder against Sid Knott in 1913, Abe retired once again. This time it would last four years. In Abe Attell's last professional bout, on January 8, 1917, he fought second-rater Phil Virgets in New Orleans. Knocked out in Round 4, the Little Champ hung up his gloves for good.

Attell was named as an accessory in the Black Sox World Series fix of 1919, accused of being a representative of notorious gambler Arnold "Big Bankroll" Rothstein. He was subpoenaed for conspiring with Rothstein and eight Chicago White Sox players to throw the World Series with Cincinnati. It was alleged that Rothstein gave Abe $100,000, which Attell distributed to eight disgruntled members of the White Sox, to throw the series. Rothstein denied complicity and managed to extricate himself from the scandal. Abe however was indicted on a conspiracy charge. He fled to Canada but returned to the United States after a year maintaining his innocence. Abe was never brought to trial for his part in the conspiracy because he was able to convince a New York grand jury investigating the fix that he was not the same Abe Attell they were looking for.

Abe Attell was married twice. When his first ended in divorce, he married Mae O'Brien in 1939. They operated a tavern in New York's Lower East Side. Abe Attell had no heirs but raised two stepchildren. In the 1960s he entered a nursing home and died at the age of 85 on February 6, 1970, in Liberty-Loomis Hospital in Liberty, New York. He is buried at Beverkill Cemetery near Rockland, New York.

The Little Champ's brilliant professional ring career lasted over 17 years. And although he claimed to have engaged in over 360 professional contests, historians are only able to document 168. He totaled 92 wins (51 knockouts), 10 loses, 18 draws, with 48 no-decisions. During his career he was the featherweight champion of the world from 1901 to 1912.

Abe Attell was inducted into the Boxing Hall of Fame (1955), the International Boxing Hall of Fame (1990), the Jewish Sports Hall of Fame (1982), and the San Francisco Boxing Hall of Fame (1985).

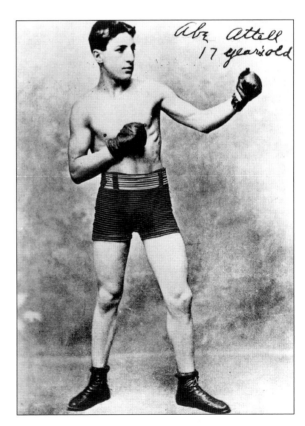

Abe Attell strikes a fighting pose in this 1901 photo.

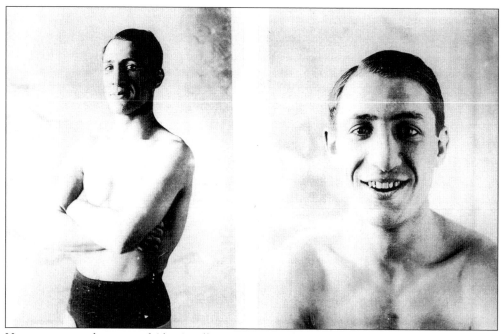

Here are two studio poses of Abe Attell as a young, professional fighter.

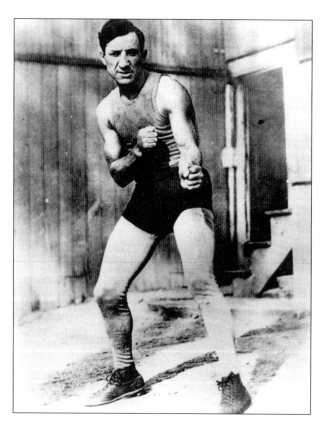

Here is Abe Attell at the end of his boxing career, *c.* 1917.

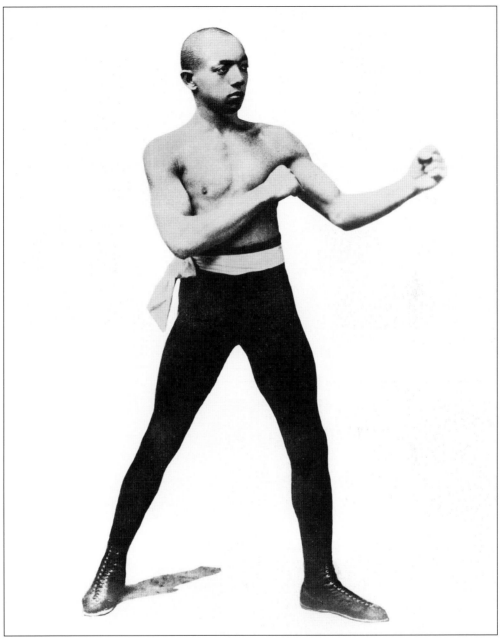

George Dixon, known as "Little Chocolate," was the first universally accepted featherweight world champion. Dixon was also the first African-American fighter to capture a world boxing title.

Featherweight Champion Abe Attell (seated right) signs a contract to defend his crown against Owen Moran on New Year's Day, 1908.

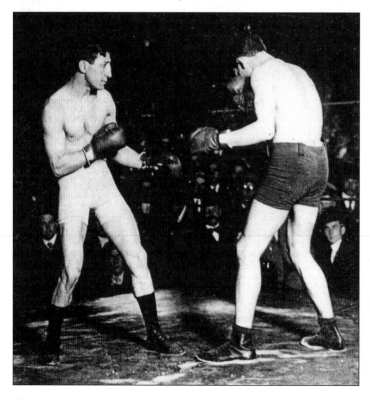

Abe Attell (left) and Battling Nelson square off before their March 31, 1908, draw at Mechanics' Pavilion.

Abe Attell (left) squares off against Owen Moran on New Year's Day 1908.

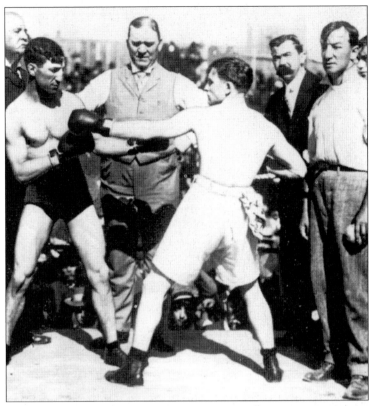

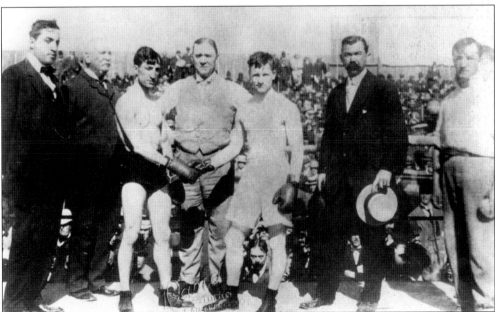

Abe Attell (left) shakes hands with Owen Moran on January 1, 1908, at Colma's Mission Street Arena. The fight ended in a 20-round draw. The man in the middle is Jack Welch, San Francisco's well-known referee. English boxing promoter Charley Harvey is the man with a moustache, and Billy Jordon, famed ring announcer of the era, stands behind Attell.

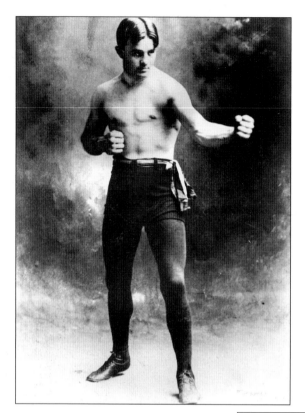

Battling Nelson, the "Durable Dane," was born in Copenhagen, Denmark, on June 5, 1882. Nelson was one of the toughest men ever to hold the lightweight title.

Charlie White, one of the great title contenders of the era, twice challenged Abe Attell for his featherweight crown in 1909, losing on points over eight rounds. The following year, White lost a newspaper decision after ten rounds.

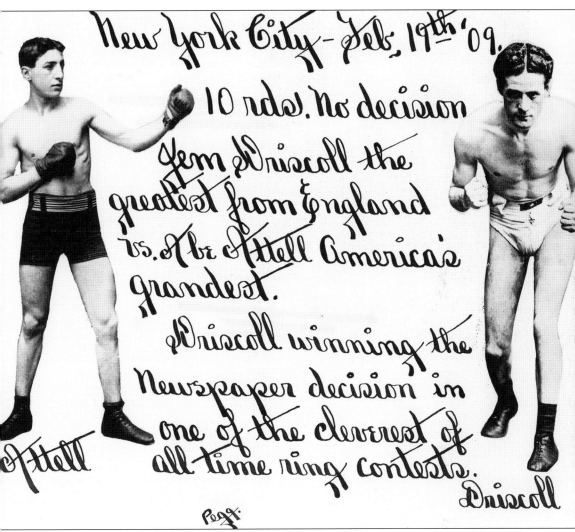

New York City - Feb, 19th '09.

10 rds. No decision

Jem Driscoll the greatest from England vs. Abe Attell America's grandest.

Driscoll winning the Newspaper decision in one of the cleverest of all time ring contests.

Attell

Pegg.

Driscoll

Abe Attell put his featherweight title on the line against British champion Jim Driscoll in 1909. Driscoll completely out-boxed and out-fought Attell but needed a knockout to win this no-decision contest.

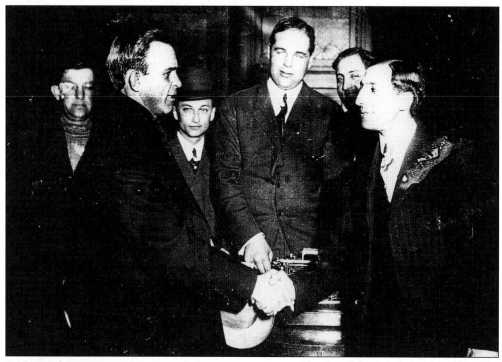

Abe Attell (right) shakes hands with Battling Nelson after signing for their March 31, 1908 fight in San Francisco. The contest was ruled a draw after 15 rounds. Boxing manager and former amateur champion Sam Berger stands between the fighters. (Courtesy of Gary Phillips.)

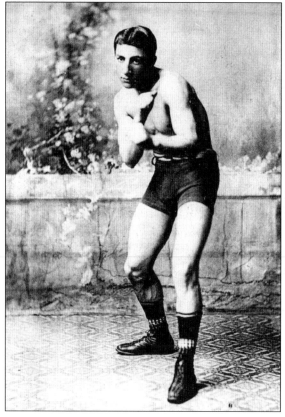

Abe Attell strikes a pose in his prime as the featherweight champion of the world in 1904. (Courtesy of Gary Phillips.)

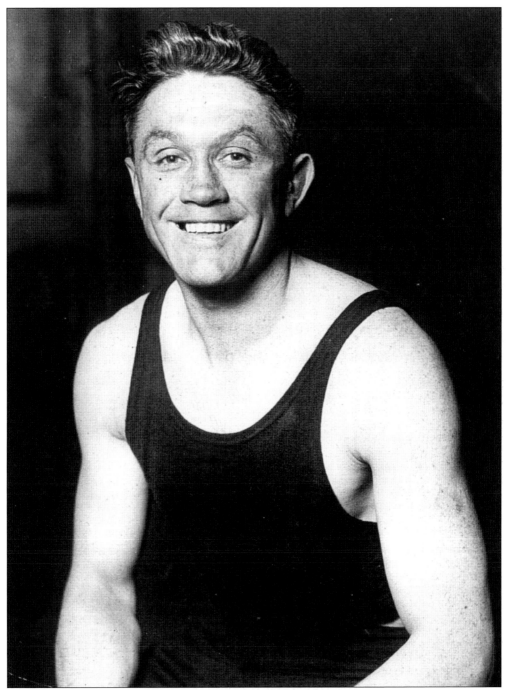

Clevelander Johnny Kilbane, pictured here, started boxing in 1907 and retired in 1923. He lost only 4 bouts in 141 contests.

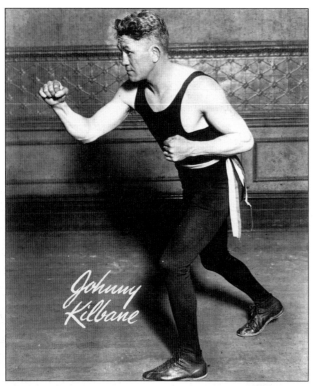

Featherweight king Johnny Kilbane assumes a fighting pose in 1920 as world champion.

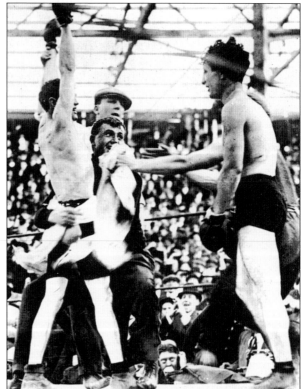

A joyous Johnny Kilbane raises his arms in victory after receiving a 20-round decision over Abe Attell. This February 22, 1912 title bout ended Attell's 11-year reign on the featherweight throne.

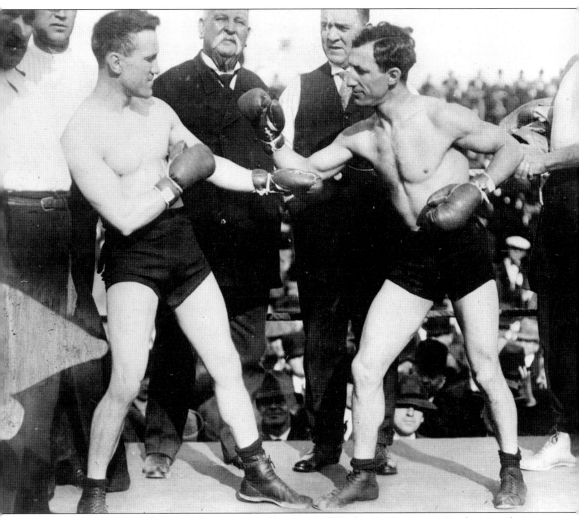

Former champion Abe Attell squares off against "Harlem" Tommy Murphy in their March 9, 1912 match in Colma. Attell entered the ring out of shape after one of his all-night gambling binges and took a severe beating in this 20-round decision loss. Attell requested an immediate rematch.

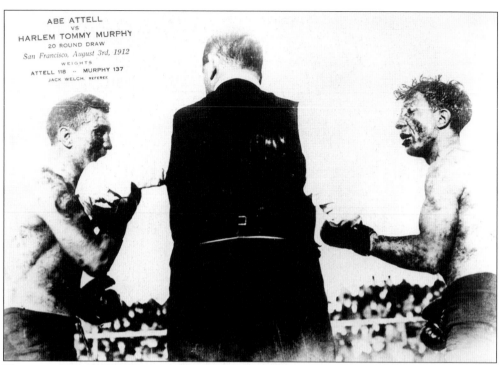

ABE ATTELL
VS
HARLEM TOMMY MURPHY
20 ROUND DRAW
San Francisco, August 3rd, 1912
WEIGHTS
ATTELL 118 — MURPHY 137
JACK WELCH, REFEREE

The second Attell-Murphy contest on August 3, 1912, was one of the bloodiest ring battles in boxing history. A witness at ringside was quoted as saying, "There was so much blood-letting from both pugilists that by the end of the fight you couldn't tell them apart. Each man was covered in blood from head to toe." After 20 rounds the fight was ruled a draw. Referee Jack Welch, with his back to camera, separates the fighters.

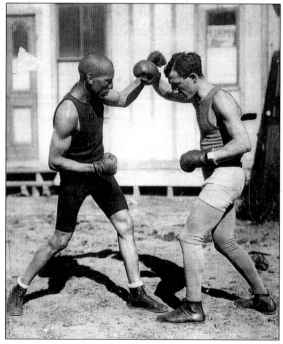

The Little Champ spars with Joe Gans in 1908. The "Old Master" was training at Croll's Garden's in Alameda, California, in preparation for his bout with Battling Nelson at Colma. (Courtesy of Gary Phillips.)

50

Abe Attell trains while in retirement in the early 1920s.

Four

FRANKIE NEIL

"IRISH FRANKIE NEIL"

Francis James Neil was born to Irish American parents in San Francisco on July 25, 1883. In spite of the fact he only stood 5 feet, $5^{1}/_{2}$ inches tall and weighed 118 pounds at his peak, Neil's superb physical skills catapulted him to the bantamweight championship of the world.

A man named Frank McDonald, who had witnessed Neil win a physical altercation with a man on Market Street who outweighed Neil by 50 pounds, is credited with discovering the fighter. McDonald, a fight manager and trainer, recommended that Neil go down to the Alec Greggains Gym on the corner of Sixth and Shipley and try his hand at boxing. It was the same gym that honed the skills of fellow San Franciscans the Attell brothers, Eddie Hanlon, and Jimmy Britt.

Before long, Frankie Neil was a member of the famed Olympic Club of San Francisco. As a junior member of the club, Neil gained his amateur experience boxing four-round matches in the Bay Area. On November 8, 1900, Neil joined the professional ranks by winning a one-round knockout over Charles Anderson. He scored an additional three straight knockouts before losing a four-rounder on points to neighborhood pal Eddie Hanlon. In 1901, Neil had 13 bouts, winning 10 by knockout and scoring 2 draws before losing a second time to the more experienced Hanlon.

Managed by his father, Jim Neil, a racing stable owner, Frankie was matched in April 1902 for a third try against his rival Eddie Hanlon. Fighting for the first time outside of San Francisco, the grueling, 15-round battle in Oakland was ruled a draw. In December, Neil was scheduled to fight Clarence Forbes, the younger brother of bantamweight champion Harry Forbes. When Clarence took ill, older brother Harry substituted for him. With Neil weighing well below the featherweight limit, the fight was billed as a bantamweight championship bout.

Outclassed by the veteran Forbes, Neil sustained a terrible beating. He was knocked down nine times in the fight before the referee finally stopped the massacre in Round 7. In his next fight, Neil was back in San Francisco at Mechanics' Pavilion in a match-up against Clarence Forbes. Neil got revenge by winning with a six-round knockout. Harry Forbes immediately requested a rematch to avenge his kid brother's shellacking. The Neil-Forbes rematch for the world title was set for August 13, 1903, in San Francisco.

Neil had learned a crucial lesson in the first fight and managed to stay out of range of Forbes's power punches. In Round 2, Neil saw an opening, caught Forbes with a left hook to the midsection, and saw the champion go down. Forbes was up at the count of nine, but Neil smothered him and would not allow him to recover. When Forbes went down for a second time, he couldn't beat the referee's count, and Frankie Neil was declared the winner and new bantamweight champion of the world.

Neil agreed to give Harry Forbes a chance to regain his crown in his hometown of Chicago on June 17, 1904. Forbes was ahead in the scoring when he ran into one of Neil's haymakers and was dropped for a count of nine. Forbes was back on his feet but still groggy from the knockdown, when a hard left hook from Neil ended the fight in Round 3.

After two non-title affairs, Neil lost his title on October 17, 1904, against English champion Joe Bowker. Frankie was out-pointed in the 20-round contest at the National Sporting Club in London.

After losing to Bowker, Frankie returned to the United States in January 1905, and continued his career. He knocked out the amateur whiz kid "Fighting" Dick Hyland in 15 rounds and won a points decision over Harry Tenny at Colma. On February 28, 1906, Neil met Tenny again and knocked him out in Round 14. Tenny collapsed and died the following day from head injuries sustained in the bout.

On July 4, 1906, Neil squared off in Los Angeles against neighborhood pal Abe Attell. They fought for Abe's world featherweight crown. Although Frankie dropped the Little Champ twice in the fight, Abe remained cool and in control and managed a 20-round decision over Neil. Their second meeting took place on January 31, 1908, in their hometown of San Francisco. This time, Attell beat Neil from pillar-to-post and ended the slaughter for good with a knockout in Round 13.

On May 6, 1908, Neil lost a 10-round decision to future lightweight champion Ad Wolgast in Milwaukee and then moved briefly to the East Coast to engage in no-decision contests. In June, Neil returned to San Francisco to face off against Abe Attell's brother Monte. The Colma bout was billed as a bantamweight championship fight. Neil took a tremendous battering and was finally knocked out in Round 18.

After several more bouts in Canada, Neil went to New York for a 10-round, no-decision return bout with Abe Attell. In February 1910, after being knocked out in Round 13 by Willie Jones in Baltimore, Frankie Neil retired from boxing. He recorded 59 bouts, with 28 wins (25 knockouts), 14 losses, 4 draws, and 13 no-decisions.

Returning to San Francisco, Neil took a job with the health department as an inspector and later worked for some time with the Standard Oil Company in Richmond, California. He eventually retired after working with the U.S. Postal Service. Frankie Neil died in 1924 at the age of 41.

This *c.* 1903 photo of Frankie Neil shows him in a classic boxing stance. (Courtesy of Gary Phillips.)

Frankie Neil stands in a fighting pose as the world bantamweight champion in 1903. (Courtesy of Gary Phillips.)

Frankie Neil shakes hands with Harry Tenny before their February 28, 1906 bout in San Francisco. Tenny was knocked out in Round 14 and died the following day from head injuries sustained in the fight. (Courtesy of Gary Phillips.)

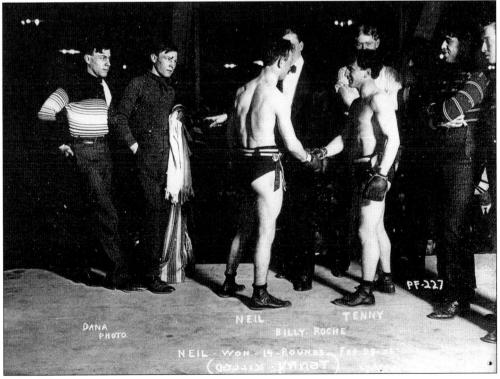

Frankie Neil spars with Leach Cross in 1905 at Billy Shannon's in San Rafael, California. (Courtesy of Gary Phillips.)

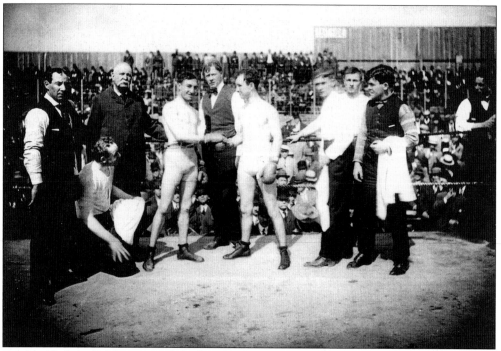

Frankie Neil (right) has a pre-fight handshake with Monte Attell before they do battle at Colma's Mission Street Arena on June 19, 1909. Neil was knocked out in Round 18, losing his bid for the vacant bantamweight world title. (Courtesy of Gary Phillips.)

In this photo, Frankie Neil squares off against Harry Forbes for the world bantamweight title on August 13, 1903. Fighting in San Francisco at the Yosemite Athletic Club, Neil won the bantamweight crown with a Round-2 knockout. (Courtesy of Gary Phillips.)

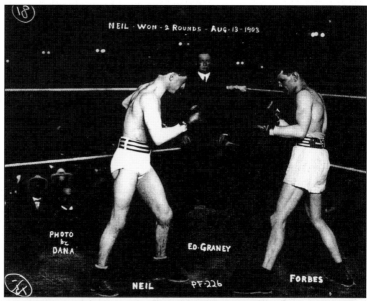

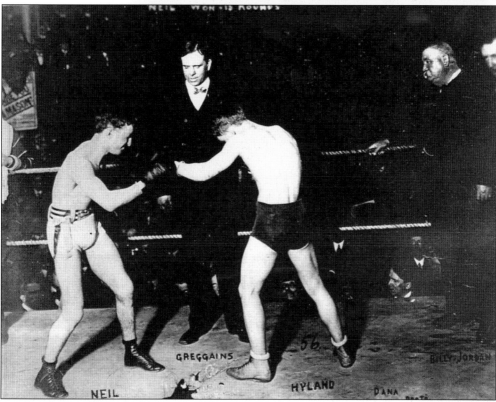

Frankie Neil holds a pre-fight pose with "Fighting" Dick Hyland in this image. The bout took place at San Francisco's Mechanics' Pavilion on January 31, 1905. Neil won the bout by knockout in Round 15. Former bare-knuckle middleweight champion Alec Greggains was the referee. Ring announcer Billy Jordon is on the right. Jordon was famous for his "let her go" signal at the start of a fight. (Courtesy of Gary Phillips.)

Five

JIMMY BRITT

"SIR JAMES EDWARD"

James Edward Britt was born in San Francisco's "South of the Slot" district on October 5, 1879. Jimmy and his older brother Willus joined the Olympic Club and learned the basics of boxing, competing as amateurs. Willus Britt's fight career was brief, but he would be remembered in boxing history as an astute manager who guided the brilliant ring careers of his brother Jimmy and the great middleweight idol Stanley Ketchel. With Willus behind him, Jimmy excelled as a fighter and turned professional in 1902.

Jimmy Britt proved to be an excellent athlete and aggressive fighter who moved up quickly in the professional ranks. The Britt bothers competition and ring earnings also escalated rapidly as Jimmy challenged the top contenders of the era. In 1902, his first year as a pro, Britt knocked out two former lightweight world champions. George "Kid" Lavigne went out in eight rounds and Frank Erne in seven at Mechanics' Pavilion. Britt jumped to better competition, bigger paydays, and 25-round contests in only his second year as a professional.

In 1903, Britt defeated top contender Willie Fitzgerald, "The Brooklyn Terror," and beat the hard-hitting Charlie Sieger in 20 rounds. In November, at Colma's Mission Street Arena, he thrashed the fearless Martin Canole over 25 rounds. The Canole win put him in line for a shot at another former champion, Young Corbett. Britt won a 20-round decision over Corbett. Britt was awarded $17,500 and a shot at the immortal Joe Gans.

On October 31, 1904, in only his 10th professional fight, Britt faced off against Gans for the lightweight world title. Britt dominated the "Old Master" throughout the contest, knocking him down four times while inflicting a terrific beating on the veteran in the process. As Gans was rising from his fourth knockdown, Britt hit him and was disqualified, keeping the 25-year-old from winning the undisputed lightweight championship of the world.

Joe Gans publicly claimed the Britt fight had been a fix, arranged between their managers. It is believed that his claim was an attempt to get a rematch with Britt. True or not, the rematch would not take place for another three years. When Gans relinquished the lightweight title because of weight problems, Jimmy Britt became the top contender for his lightweight crown.

In December 1904, Jimmy Britt had the first of a four-bout series with the legendary Oscar Matthew Nielson, who fought under the moniker Battling Nelson. Their fight took place at San Francisco's Mechanic's Pavilion for the lightweight championship of the world. This fight demonstrated Britt's remarkable fighting skills and ring generalship as he moved, jabbed, and frustrated his foe. With Nelson unable to solve Britt's slick style, Britt was awarded the decision and the world lightweight championship after 20 rounds.

Britt defended his title twice in 1905 in San Francisco against Jabez White and Kid Sullivan, winning both. In September he faced off in a rematch with Battling Nelson at Mission Street

Arena. Boxing promoter "Sunny Jim" Coffroth, who owned the arena, believed that Britt-Nelson II would be a tremendous draw, so he put up the $20,000 to make the fight a reality.

Fans and opponents referred to Jimmy Britt as "Sir James Edward," a nickname he acquired due to his penchant for stylish dress. Always dashing in his Prince Albert–style coat, bowler hat, and fancy walking cane, Britt was the antithesis of his rival, Battling Nelson. Nelson was a crude, no-nonsense fighter with little formal education. The difference in styles and temperament made for a classic match.

Advertised as a title fight, their September 9, 1905 bout was scheduled for 45 rounds. From the start, Nelson initiated the attack and Britt fought defensively. In Round 18, Nelson caught Britt with a punch to the heart, followed by a quick, three-punch combination. Paralyzed momentarily, Britt fell backwards, unconscious. Jimmy Britt was now the "former" champion of the world.

In May 1906, Britt fought a 10-round, no-decision contest with "Terrible" Terry McGovern and then scored a 20-round win over Battling Nelson in a non-title encounter. Britt was then matched with Joe Gans, who had taken the lightweight title back from Battling Nelson the year before. The Britt-Gans fight on September 9, 1907, was held at Recreation Park in San Francisco for Gans's lightweight championship. From the opening bell, Britt took control of the fight and dominated the action until sustaining a wrist fracture in Round 4. From then on it was all Gans until the bout was stopped in Round 6.

In 1908, Britt sailed to London for a three-fight series with Englishman Johnny Summers. Britt won their first meeting in 10 rounds, and in their second encounter, Britt was out pointed over 20 rounds. Their third meeting was considered a classic and one of the best fights ever seen in England. In Round 2, Britt was dropped to the floor from a hard right to the jaw. Staggering to his feet at the count of nine, Britt threw a wild right and caught Summers square on the jaw, dropping him—the bell saved Summers from a knockout. From Round 3 until Round 9, the fight was a closely contested affair until Britt was knocked out by a Summers right hand.

In retirement from the ring, the dapper and well-spoken Sir James Edward made a successful transition to the vaudeville stage and became a very successful performer. Jimmy Britt, San Francisco's native son, lived until January 29, 1940, when he died of a heart attack at his home in the Bay Area. He was 60 years old. Over his short career Britt recorded 24 bouts with 13 wins, (5 knockouts), 8 loses, and 1 draw. Jimmy Britt was elected to the Ring Boxing Hall of Fame in 1976.

Willus Britt, the self-described theatrical impresario, pool hustler, candy butcher, actor, and con man, enjoyed a successful career as the fight manager of middleweight sensation Stanley Ketchel. Willus died suddenly of a heart attack shortly after Ketchel was murdered in 1910.

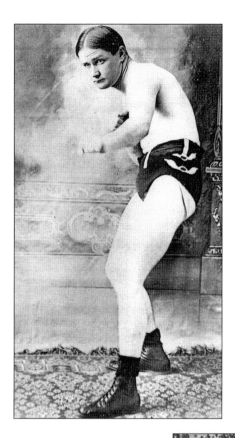

Jimmy Britt poses here for the camera in 1905. (Courtesy of Gary Phillips.)

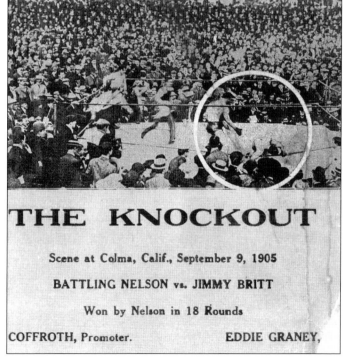

THE KNOCKOUT

Scene at Colma, Calif., September 9, 1905

BATTLING NELSON vs. JIMMY BRITT

Won by Nelson in 18 Rounds

COFFROTH, Promoter. EDDIE GRANEY,

This 1905 headline from a rare newspaper describes the outcome of the Nelson-Britt fight at Colma. In a pro career that only spanned 25 fights, 4 of them were against Battling Nelson. The final score was 2-1-1 for Britt. (Courtesy of J.J. Johnston.)

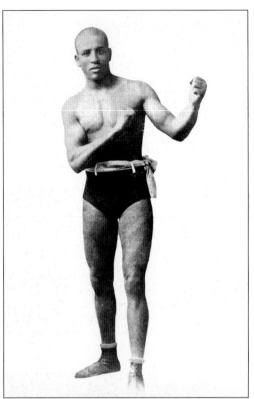

Joe Gans, "The Old Master," was born in Baltimore on November 25, 1874. One of the great ring-generals of all time, Gans had two classic battles with Jimmy Britt, winning both amid controversy.

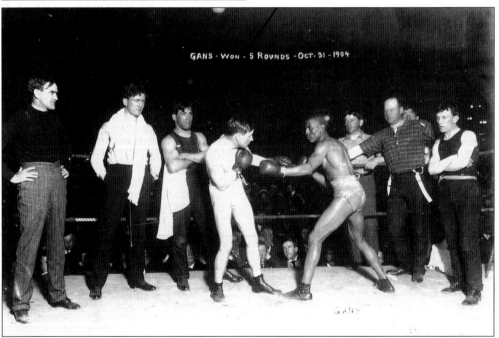

GANS - WON - 5 ROUNDS - OCT. 31 - 1904

Jimmy Britt and Joe Gans face off at San Francisco's Mechanics' Pavilion before their world title bout held on October 31, 1904. Britt put Gans down several times in the fight but was disqualified for hitting Gans as he tried to rise from a knockdown.

Jimmy Britt poses during training at Billy Shannon's in San Rafael, California, in 1905. (Courtesy of Gary Phillips.)

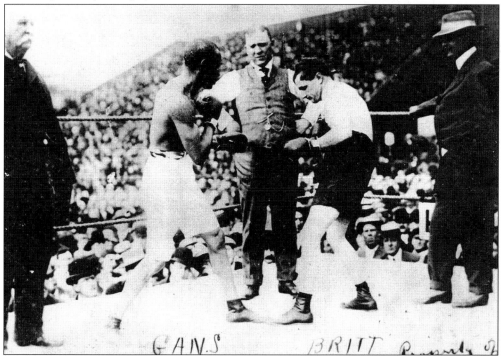

Jimmy Britt (right) and Joe Gans square off at center ring before their 1908 rematch at Recreation Park in San Francisco. The referee between the fighters is Jack Welch, while outside of the fighters are ring announcer Billy Jordon (left) and Willus Britt (right), Jimmy's brother and manager. (Courtesy of Gary Phillips.)

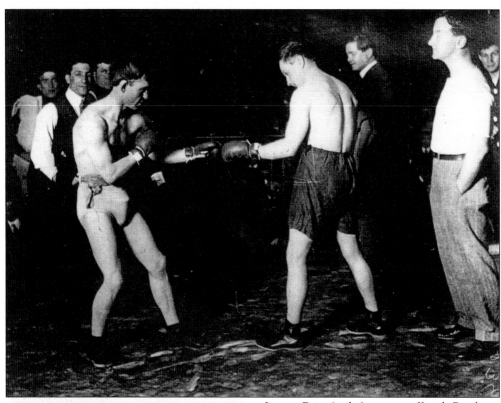

Jimmy Britt (right) squares off with Battling Nelson before their 1904 lightweight title fight at Mechanics' Pavilion in San Francisco. Britt won the contest and the vacant lightweight championship of the world with a 20-round decision. (Courtesy of Gary Phillips.)

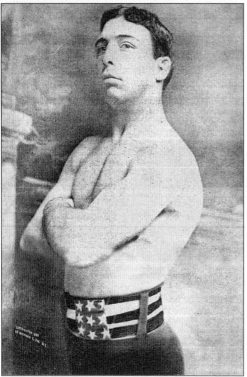

George Green, known as "Young Corbett," lost a 20-round decision to Britt at Woodward's Pavilion on March 25, 1904.

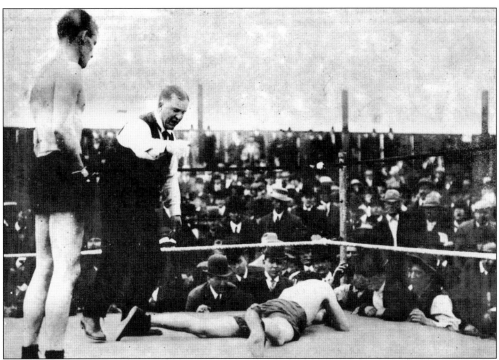

In this 1908 bout, top lightweight contender Packy McFarland knocked out former champ Jimmy Britt. Britt was unable to rise as referee Jack Welch counted to 10 over him. Britt's corner tried in vain to coax him off the canvas. In 48 bouts, McFarland scored 33 knockouts but never got a chance at the title.

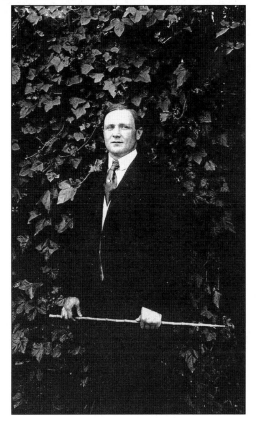

Jimmy Britt retired to a successful career on the vaudeville stage, dying in 1940 at the age of 60. (Courtesy of Gary Phillips.)

Six

MONTE ATTELL

"THE NOB HILL TERROR"

Monte Attell, "The Nob Hill Terror," was born in San Francisco on July 28, 1885 and was the youngest brother of featherweight king Abe Attell. Monte began his pro boxing career in 1903 at San Francisco's Mechanics' Pavilion, winning a six-round decision over Bobby Johnson.

Undefeated in his first two years as a pro, Attell lost by technical knockout in 1905 to the bantamweight champion Jimmy Walsh and dropped two point-decisions to former champ Owen Moran. After a knockout loss to Harry Tenny in his next contest, Attell would remain undefeated for the next five years. On December 28, 1908, Monte won a decision over Walsh. Soon afterward Walsh vacated the bantamweight division to campaign as a featherweight, making Monte Attell the top contender for his bantamweight world title.

On June 19, 1909, at Colma Arena, Attell knocked out childhood pal and former champ Frankie Neil in 18 rounds to claim the bantamweight crown. Attell overwhelmed Neil from the start and dropped him in Round 15 with a left to the body. Neil tried desperately to survive, but another solid left hook to the head in the Round 18 ended the fight. Frankie Neil, the bantamweight world champion from 1902 to 1904 was finished as a world champion. When Monte won the bantamweight championship of the world in 1909, it marked the first time in history that brothers held world boxing titles simultaneously.

Attell fought to a draw with Danny Webster in December 1909 with his bantamweight title on the line. In his next title defense on February 22, 1910, Attell was knocked out in Round 42 by Frankie Conley in Vernon, California. Italy's 19-year-old Frankie Conley was the new bantamweight world champion.

In March 1911, Attell took on top featherweight contender Johnny Kilbane and lost a 10-round decision in Cleveland. The following year, Kilbane would win brother Abe's featherweight world title. In December 1912, Monte returned to Kilbane's hometown of Cleveland to challenge Kilbane for his featherweight crown. Kilbane proved too much for "The Nob Hill Terror" and he was stopped in Round 9.

Attell continued his career but never again challenged for the world championship. On September 6, 1916, Monte Attell climbed through the ropes for the last time against future bantamweight champion Joe Lynch. Attell was forced to retire after suffering a severe eye infection, which caused him to go blind. Monte Attell recorded a professional ring record of 34 wins, 22 losses, 14 draws, 27 no-decisions, and 2 no-contests.

In retirement, Monte Attell sold newspapers in his hometown of San Francisco and died there in 1960 at the age of 75. His oldest brother, Caesar, who had a brief professional career in the early 1900s, died in 1979, thereby ending the fabulous Attell sports dynasty.

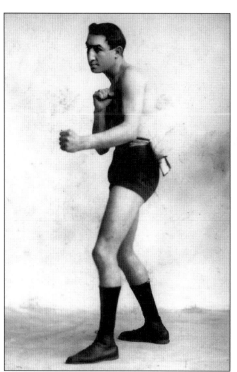

Monte Attell displays a classic boxing pose in this 1910 image.

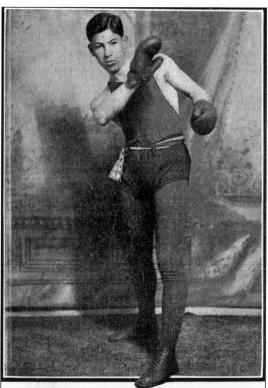

YOUNG MONTE ATTELL, A 105-POUNDER.

Monte Attell is shown here as a bantamweight contender in 1906.

Displayed here is the Monte Attell and Frankie Conley poster recapping their 1910 bout for the bantamweight world championship.

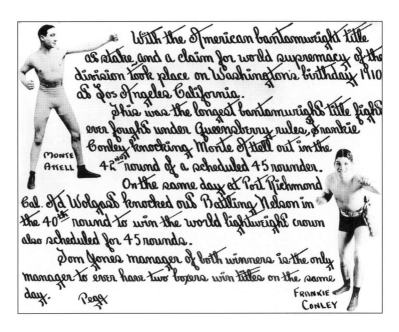

With the American bantamweight title as stake, and a claim for world supremacy of the division took place on Washington's birthday 1910 at Los Angeles California.

This was the longest bantamweight title fight ever fought under Queensberry rules, Frankie Conley knocking Monte Attell out in the 42nd round of a scheduled 45 rounder.

On the same day at Port Richmond Cal. Ad Wolgast knocked out Battling Nelson in the 40th round to win the world lightweight crown also scheduled for 45 rounds.

Tom Jones manager of both winners is the only manager to ever have two boxers win titles on the same day.

MONTE ATTELL
FRANKIE CONLEY
Pegg

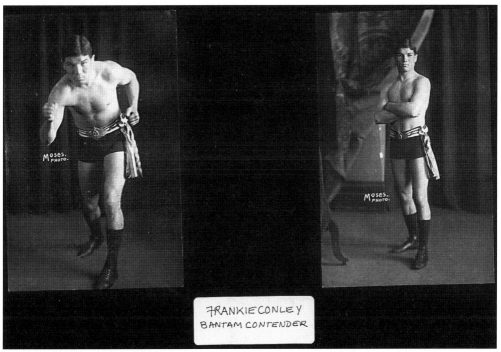

FRANKIE CONLEY
BANTAM CONTENDER

These are 1910 studio poses of Frankie Conley as the world bantamweight champion. (Courtesy of Bustout Productions.)

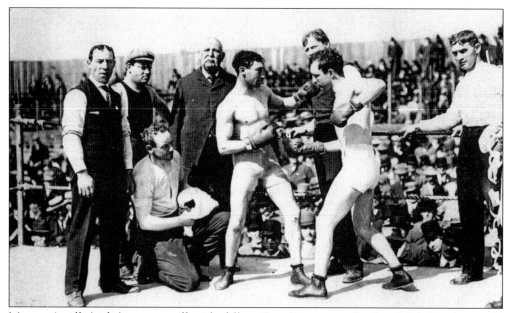

Monte Attell (right) squares off with fellow San Franciscan Frankie Neil for the world bantamweight championship at Coffroth's Colma Arena. Attell won with a knockout in Round 18.

Monte Attell (left) and brother Abe strike poses here for the camera. When Monte Attell won the bantamweight crown in 1909, it marked the first time brothers held world boxing titles simultaneously. (Courtesy of J.J. Johnston.)

In this 1910 studio photo, Monte Attell demonstrates his winning form. (Courtesy of Gary Phillips.)

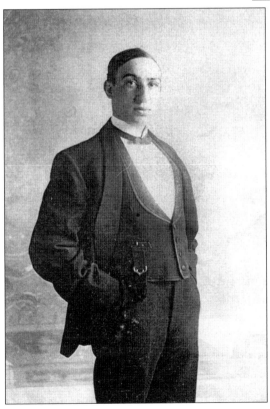

This 1909 shot shows Monte Attell wearing formal dress as the bantamweight champion of the world. (Courtesy of Gary Phillips.)

Seven

WILLIE RITCHIE

"SAN FRANCISCO'S LIGHTWEIGHT SENSATION"

Willie Ritchie, christened Gerhardt Anthony Steffen, was born in San Francisco on February 13, 1891. One of 11 children (4 girls and 7 boys), he was named after Father Gerhardt, the priest who baptized him at the local Catholic church where he later served as an altar boy. His early ambition was to become a baseball star like his brother Frank, a semi-pro catcher.

Ritchie's South of Market Street neighborhood was bursting with professional ring talent. On his daily walks past the San Francisco Athletic Club, he'd watch the training of neighborhood idols like James Corbett, Jimmy Britt, Nonpareil Jack Dempsey, Spider Kelly, Joe Choynski, and the Attell brothers. After witnessing the Jeffries-Sharkey and Corbett-Jeffries bouts peeking through the skylight at Mechanics' Pavilion, Willie Ritchie knew he was destined to become a fighter.

Working as a gym assistant from the age 14, he launched his own boxing career in 1907. Pushed into the ring as a last-minute substitute for another fighter, Geary Steffen was introduced by the ring announcer as the no-show Willie Richardson. Matched against a seasoned professional named Eddie Steel, "Willie" took a brutal beating before the referee finally halted the slaughter in Round 2. The next day a typographical error in the newspaper gave the loss to Willie Ritchie. He kept the "nom de guerre" to hide his fistic ambitions from his disapproving father. Willie's older brothers eventually convinced their father that Willie had great potential as a fighter.

By 1911, Ritchie had recorded an impressive win streak against some of the best lightweights on the Pacific Coast. He made a name for himself, winning a four-round match over Jack Britton. On November 28, 1912, Willie was again a last-minute replacement, substituting for the lightweight champion Ad Wolgast, "The Michigan Wildcat." With Wolgast stricken with appendicitis, Ritchie was matched against a brilliant fighter from Wales named Freddie Welsh.

Willie lost a close fight over 20 rounds but scored the only knockdown in the fight. Welsh, a jab artist, out-classed Ritchie, but the fight gave Willie national exposure when the following day's newspaper headlines announced "a preliminary fighter from San Francisco came out of the audience last night to give the savvy Freddie Welsh the fight of his life." The pugnacious San Franciscan's stunning performance catapulted him to the top of the contender list for the lightweight crown.

In May 1912, Ritchie faced off against Wolgast in a four-round, no-decision contest in San Francisco. After a tune-up fight against top contender Joe Mandott, Willie Ritchie was ready to challenge "The Michigan Wildcat" for his lightweight crown.

On Thanksgiving Day 1912, 21-year-old Ritchie climbed into the ring at the Mission Street Arena to challenge Ad Wolgast for the lightweight championship of the world. Ritchie entered

the ring a 5-1 underdog in a controversial bout that would be talked about for years to come. In Round 16 of a bloody contest, Ritchie, with both eyes nearly swollen shut, landed a right haymaker on the chin of Wolgast, followed by a hard left that put the champion down. Dazed, Wolgast rose to his feet at the count of five, clinched Ritchie, and threw a powerful left hook below the belt. Ritchie dropped to the canvas holding his groin. Referee Jim Griffin determined it was a deliberate and intentional low blow and stopped the contest, awarding the fight and Wolgast's lightweight crown to Ritchie. It was only the second time in lightweight history that a title changed hands on a foul (the first time was in 1872 when Billy Edwards lost the lightweight title to Art Chambers at Squirrel Island, Canada).

After winning the title, Ritchie inadvertently changed the lightweight weight minimum from 133 to 135 by declaring that he would now defend the lightweight crown at the higher weight. The controversial ending to the title fight guaranteed a return match with ex-champion Wolgast. Willie Ritchie was now the new lightweight king of the world and the road ahead was paved with gold.

On July 4, 1913, Ritchie made the first defense of his crown against rugged "Mexican" Joe Rivers. Ritchie received $18,000 in a brutal battle that cut down Rivers in Round 11. Then Ritchie went east to collect $10,000 and win a newspaper decision over Leach Cross at Madison Square Garden.

On March 11, 1914, Ritchie had his rematch with Wolgast. He picked up another $16,000 in the non-title defense that ended in a no-decision after 12 rounds. In his knockdown, drag-out title defense against "Harlem" Tommy Murphy in San Francisco the following month, Ritchie collected a $15,300 purse. After a 10-round, no-decision bout over Chicago's Charlie White, Ritchie grabbed another $10,000. Between Ritchie's ring earnings and his vaudeville appearances, he was the highest paid lightweight in history until Benny Leonard hit his peak in the mid-1920s. For a hefty guarantee of $25,000, Willie was persuaded to cross the pond and defend his title against Freddie Welsh at the National Sporting Club in London. After 20 rounds the fight ended amid controversy when referee Eugene Corri awarded the fight and the world lightweight championship to Welsh by a single point. Willie Ritchie's title reign was over.

Four months later Ritchie resumed his career, fighting a four-round, no-decision affair against future featherweight king Johnny Dundee. In 1915, he boxed no-decision contests with champions Welsh, Johnny Dundee, and then welterweight champ Ted (Kid) Lewis. When the United States entered World War I, Ritchie join the Army and was sent to Ft. Lewis, Washington, where he served as an athletic instructor.

In February 1919, after his discharge from the Army, Ritchie returned to the ring with two fights against the great Benny Leonard, who has been called the greatest 135-pound titleholder of all time. The first bout in Willie's hometown ended in a four-round, no-decision verdict. In New York for his honeymoon in April 1919, Ritchie took $10,000 for a rematch with Leonard. Willie made a gallant effort, but Leonard proved too fast and strong for the San Franciscan. He was knocked out in Round 8, marking the only time in Ritchie's career that he was ever stopped.

After the Leonard bout, Ritchie retired but made several comeback attempts over the next five years. He ventured into vaudeville, promoted fights, refereed, and tried various business ventures. He hung up the gloves for good after winning three bouts in 1927. Ritchie finished his ring career with a record of 71 contests, 36 wins, (8 knockouts), 4 draws, 9 defeats (1 by knockout), and 22 no-decision verdicts.

In retirement he owned a Chevrolet dealership, a tire company, and an apartment building in San Francisco. Ritchie served as assistant chief inspector of the California Athletic Commission from 1934 to 1937 and chief inspector until he retired in 1962. He was elected into the Boxing Hall of Fame in 1962, and died March 24, 1975, in Burlingame, California.

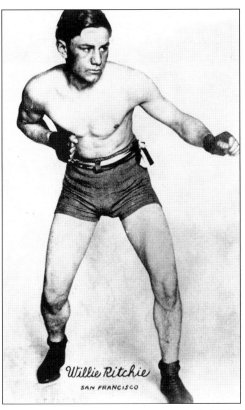

Willie Ritchie displays perfect boxing form in this 1913 photo.

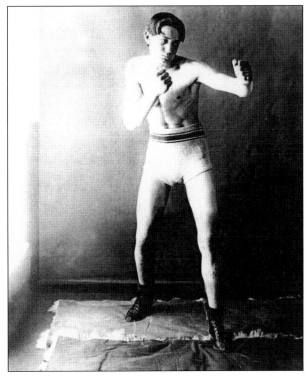

This is a studio pose of Willie Ritchie in 1912, when the 21-year-old was lightweight champion of the world. (Courtesy of Gary Phillips.)

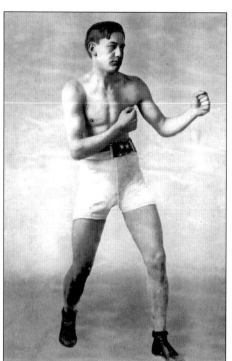

Lightweight champion Willie Ritchie poses for the camera in 1912. (Courtesy of Gary Phillips.)

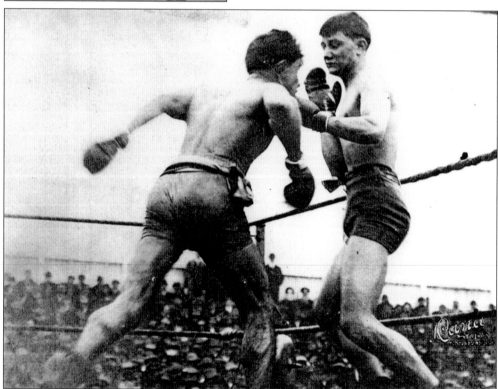

Willie Ritchie is shown here on his way to winning the lightweight championship of the world against Ad Wolgast in 1912. Ritchie won the Colma, California, contest on a foul in Round 16.

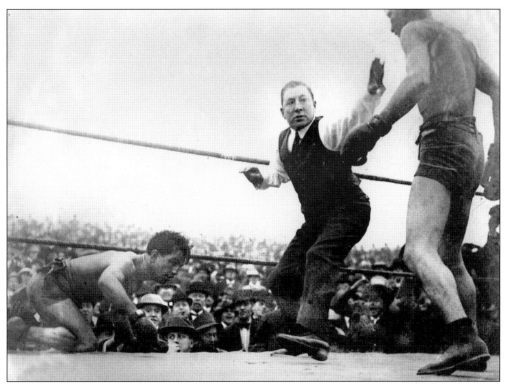

Referee Jim Griffin waves Ritchie off after he drops the "Michigan Wildcat" with a well-timed left hook. Moments later Ad Wolgast would throw a punch below Ritchie's belt and lose the bout and his lightweight title on a foul.

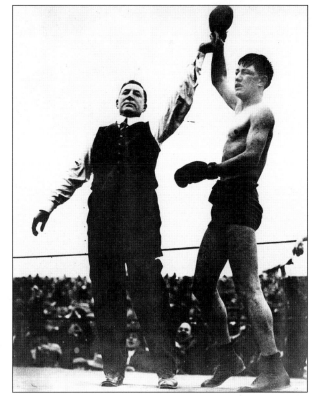

Referee Jim Griffin raises Ritchie's hand after winning Ad Wolgast's world lightweight title in Round 16 on November 16, 1912.

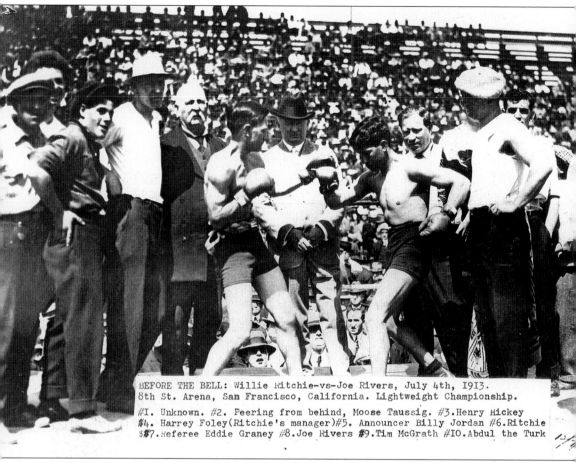

BEFORE THE BELL: Willie Ritchie-vs-Joe Rivers, July 4th, 1913.
8th St. Arena, San Francisco, California. Lightweight Championship.

#1. Unknown. #2. Peering from behind, Moose Taussig. #3.Henry Hickey
#4. Harrey Foley(Ritchie's manager)#5. Announcer Billy Jordan #6.Ritchie
#7.Referee Eddie Graney #8.Joe Rivers #9.Tim McGrath #10.Abdul the Turk

Willie Ritchie squares off with "Mexican" Joe Rivers in this Fourth of July 1913 brawl at the outdoor Eighth Street Arena in San Francisco. Ritchie won by knockout in Round 11 in his first lightweight title defense.

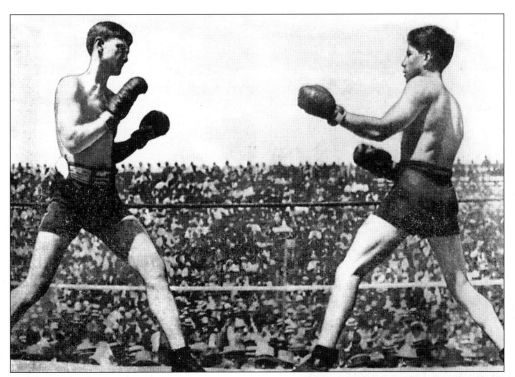

Willie Ritchie is seen here in action against Mexican Joe Rivers on the Fourth of July, 1913.

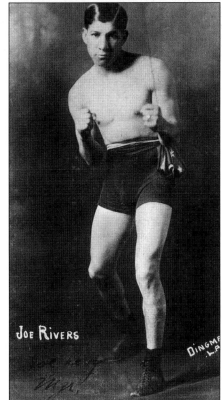

Born Jose Ybarra in Los Angeles in 1891, Mexican Joe Rivers was one of the top contenders in the lightweight division for over a decade. Mexican Joe lost twice in his bid for the world lightweight title. Ad Wolgast beat Rivers in 1912 in a controversial decision and Willie Ritchie stopped Rivers in his first title defense in 1913.

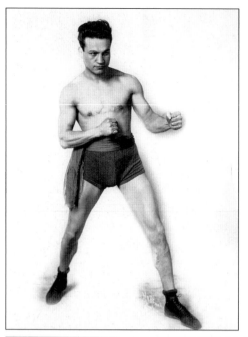

Top lightweight contender Charlie White is shown here around 1914. Between winning the lightweight crown and his first defense against "Harlem" Tommy Murphy, Ritchie fought Chicago's left-hook artist Charlie White. Though the fight ended in a no-decision, White was given the newspaper nod. (Courtesy of Jack Barloon.)

Ritchie prepares for a fight at Millett's Training Quarters near San Francisco in 1912.

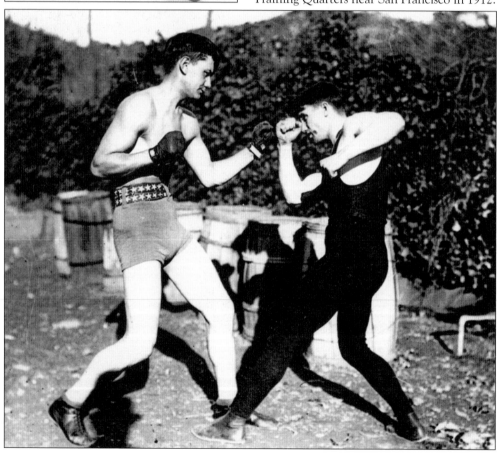

Frederick Hall Thomas, or "Freddie Welsh," out-pointed Ritchie for his lightweight crown in 1914. A master boxer and world champion, Welsh brought a flair and dignity to the sport. A true gentleman, Welsh was actually urged to run for British parliament. "I am honored," he said, "but I prefer boxing." Freddie Welsh wore the crown until Benny Leonard defeated him in 1917.

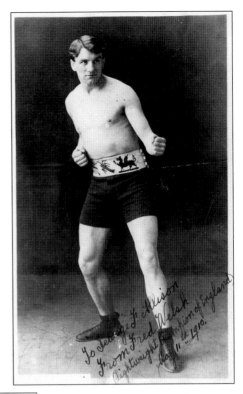

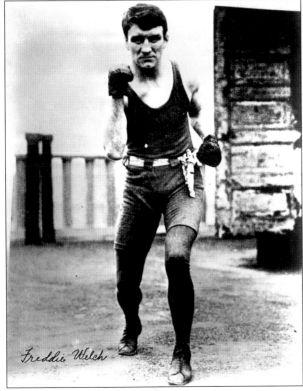

Freddie Welsh, "The Welsh Wizard," was born in Wales in 1886 and began a professional boxing career that spanned from 1905 to 1922. He engaged in 165 contests, winning 101. Freddie Welsh died in 1927 at the age of 41.

Eight

CONTENDERS AND TITLE CLAIMANTS

Dal Hawkins was born in San Francisco in 1871 and started his professional career there in 1887. In 1889, Hawkins beat Fred Bogan for the world featherweight title in a 90-round fight that was halted after 75 rounds and continued the following day.

In 1892, fighting as a welterweight, Hawkins recorded two knockout losses to future champ Solly Smith in San Francisco. In 1899, Hawkins was knocked out in a non-title fight with welterweight champ Frank Erne at Woodward's Pavilion. In the last main event, Hawkins lost by disqualification to George "Elbows" McFadden in San Francisco. He retired from the ring in 1905 with a career mark of 16 wins, (12 knockouts), 13 losses, and 4 draws.

In 1904, Eddie Hanlon knocked out "Kid" Broad at Mechanics' Pavilion and had two loses at the venue against Battling Nelson and "Terrible Terry" McGovern. Hanlon's last major contest in San Francisco was a 20-round decision loss to the former bantamweight champ Owen Moran. Eddie Hanlon retired from the ring in 1914 at the age of 28. He left with a career mark of 41 total bouts 17 wins (10 knockouts), 11 losses, and 7 draws.

San Francisco's Eddie De Campus, known as Eddie Campi, claimed the bantamweight world title during the golden age. Born in San Francisco on the Fourth of July 1893, Campi made his professional debut in 1910 against Joe Sullivan. He built an impressive win record fighting on the Pacific Coast, losing only once in his first 25 contests.

In 1913, Campi beat Charles Ledoux in Vernon, California, for the IBU bantamweight world title. He lost the IBU title one year later to Kid Williams. Campi continued his career on the East Coast until moving west again in 1917. Eddie Campi died in 1918 at the age of 24. He recorded a professional ring record of 69 total bouts with 38 wins (8 knockouts), 7 losses, and 8 draws.

Sam Berger was born in Chicago, Illinois, in 1884 but was raised in San Francisco and adopted as a native son. Berger had a remarkable amateur boxing career, winning the middleweight title of the Pacific Coast in 1901 and the heavyweight title in 1902. Representing the Olympic Club of San Francisco, Berger became the first Olympic heavyweight champion, winning the gold medal at the 1904 St. Louis Games.

Johnny Frayne, known as "Rapid Fire," was another local fighter who recorded some impressive names on his ring record during his short career. He was born in San Francisco in 1888 and started his boxing career in 1907. In 1909, he fought a no-decision bout with Freddie Welsh and knocked out Young Corbett in eight rounds at Colma.

In October 1910, Frayne recorded a draw against "Harlem" Tommy Murphy and another against Owen Moran, before losing on a points verdict to "One Round" Hogan at Blot's Arena in San Francisco. Frayne retired from the ring in 1912 with a career mark of 6 wins (2 knockouts), 4 losses, and 4 draws.

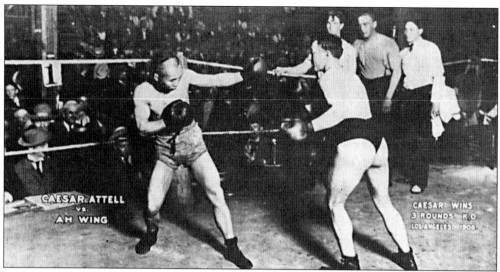

Caesar Attell faces off with Ah Wing before their 1906 matchup. Caesar, the oldest of the fighting Attell brothers, had a professional career that lasted from 1902 to 1906.

Dal Hawkins won the featherweight crown in 1889, wearing newly introduced two-ounce gloves that ended bare-knuckle championship bouts in the weight division.

Eddie Hanlon was born Charles Walter Hanlon in the Telegraph Hill section of San Francisco on October 2, 1885. He began his pro ring career at age 15 as a lightweight. A hometown favorite attraction, Hanlon faced off against future world champions Abe Attell, Frankie Neil, and Young Corbett.

Eddie Hanlon dons gloves while training at Croll's Garden's in early 1900.

Eddie Hanlon spars at Croll's Garden's with middleweight contender Hugo Kelly.

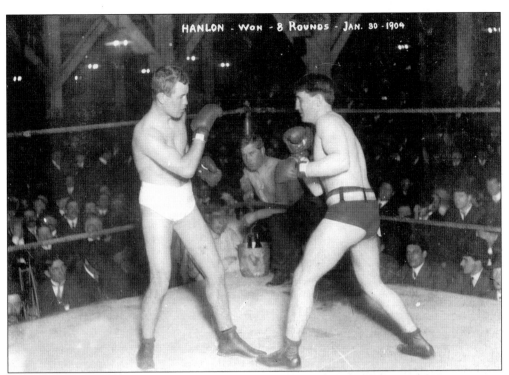

Eddie Hanlon (right) and Ned "Kid" Broad are pictured here before their January 30, 1904 bout at Mechanics' Pavilion. Hanlon won the fight with a Round-8 knockout.

Eddie Hanlon strikes a studio pose in 1902. Having started in the fight game as a 15-year-old, Hanlon's skills were diminished by the time he reached his mid-20s. After a layoff that lasted several years, Hanlon attempted an ill-fated comeback and finally retired from the ring at 28.

Al Kaufman, the "Great White Hope," was a heavyweight contender. Kaufman was born, in 1886, and raised in San Francisco. Starting his professional career in 1904, he became one of the many "Great White Hope" contenders for Jack Johnson's heavyweight crown. During his career, Kaufman faced off and beat some of the best fighters of the era, including "Fireman" Jim Flynn, Jack "Twin" Sullivan, and former light-heavyweight champ George Gardner. At Colma in 1909, Kaufman fought a 10-round, no-decision contest with Jack Johnson for his heavyweight title.

Al Kaufman, pictured here c. 1910, is ready for action. After losing to other "Great White Hope" contenders such as Al Palzer and Luther McCarty, Kaufman retired from the ring in 1913. His record was 24 wins (18 knockouts), 8 losses, 1 draw, and 4 no-contests.

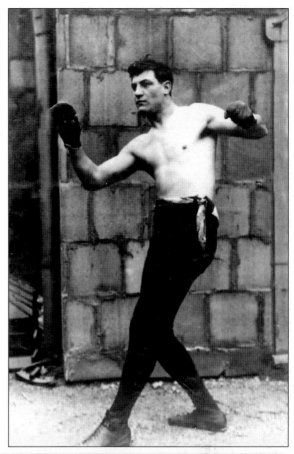

Al Kaufman (right) poses here with Charlie Miller before their 1911 clash. Miller won this four-round heavyweight contest at San Francisco's Dreamland Rink Arena. Harry Foley, Kaufman's manager, is at the far right holding Kaufman's robe.

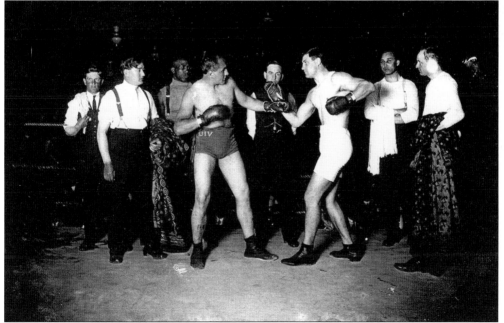

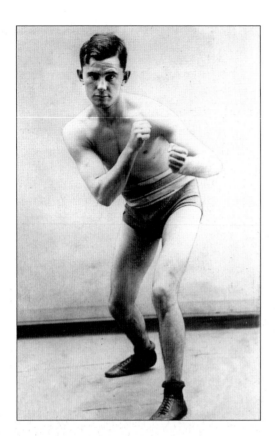

San Fransisco's Eddie Campi, photographed here in 1913, claimed the bantamweight title in the same year.

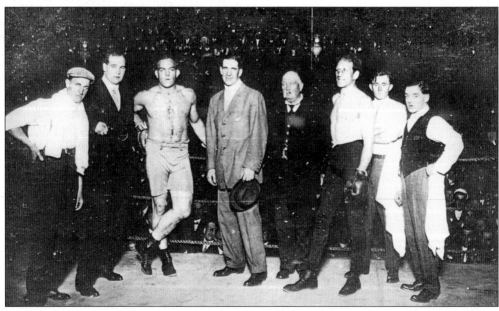

Amateur champion Sam Berger is seen here second from left. Berger served as Jim Jeffries' manager during his 1910 comeback against Jack Johnson. To Berger's left is Jeffries, Jim Corbett, Billy Jordon, and Joe Choynski.

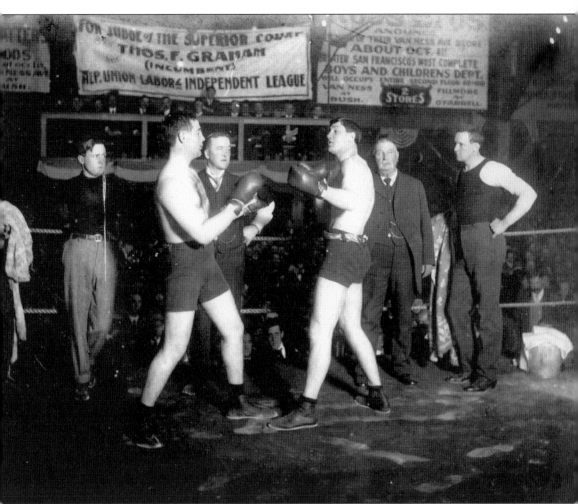

Sam Berger (left) squares off against Al Kaufman in their October 31, 1906, contest at San Francisco's Pavilion Rink. Kaufman won by knockout in 10 rounds, ending Burger's aspirations as a professional fighter. Between the fighters is referee Jack Welch, and standing behind Berger is lightweight champion Jimmy Britt. Berger turned professional after the Olympics but only fought two years, including a six-round, no-decision win against light-heavyweight champion "Philadelphia" Jack O'Brien in 1906. After retiring, Berger became Jim Jeffries's sparring partner and manager during Jeffries's comeback against Jack Johnson. Sam Berger had a successful clothing business in San Francisco until he passed away on February 25, 1925, at the age of 40.

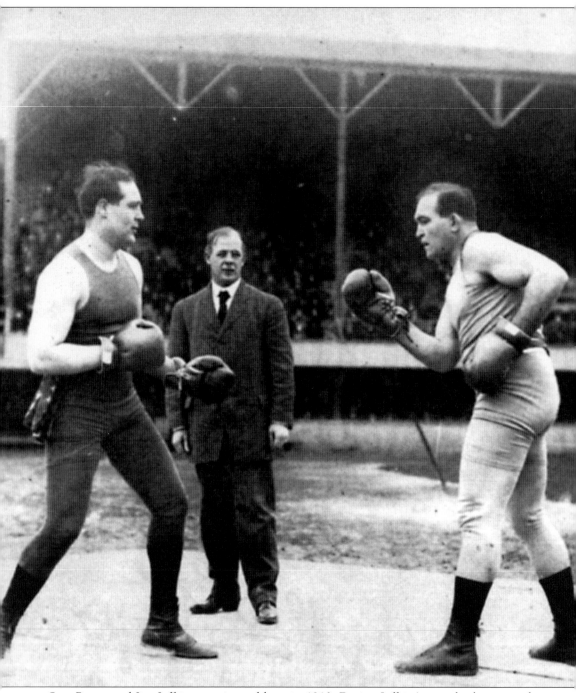

Sam Berger and Jim Jeffries are pictured here in 1910. During Jeffries's comeback against the first African-American heavyweight champion, Jack Johnson, Berger served as Jeffries's manager and training partner. Here, Berger spars with Jeffries before a crowd at San Francisco's Recreation Park with referee Eddie Smith looking on. Shortly after this photo was taken, Jeffries moved his training camp to Reno, Nevada, where the Jeffries-Johnson bout took place. Jeffries lost the Johnson bout by way of a 15-round knockout.

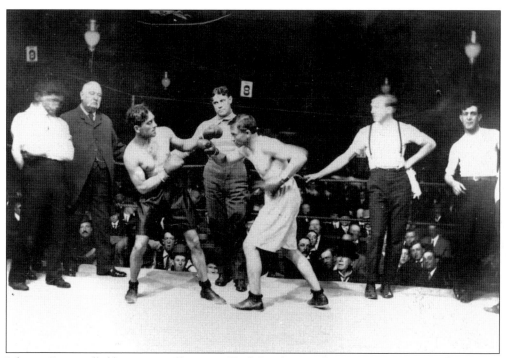

Johnny Frayne (left) squares off against Fred Lauders in San Francisco on April 4, 1908, a lightweight bout he won by a points decision after 15 rounds. Joe Thomas stands between the fighters.

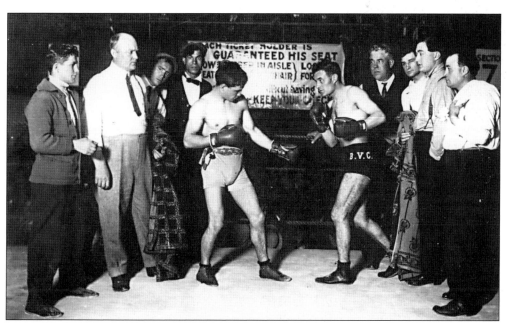

San Francisco's Anton LaGrave (right) poses prefight with Ad Wolgast. Wolgast won the March 31, 1911 contest at San Francisco by TKO in five rounds.

Nine
LEGENDARY CHAMPIONS COME TO TOWN

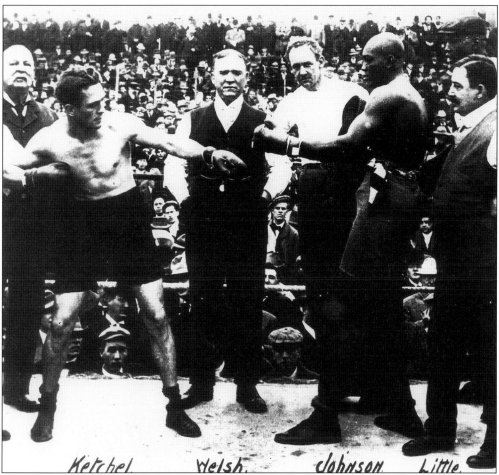

Ketchel. Welsh. Johnson. Little.

Middleweight king Stanley Ketchel (left) faces off against heavyweight champion Jack Johnson in this photograph.

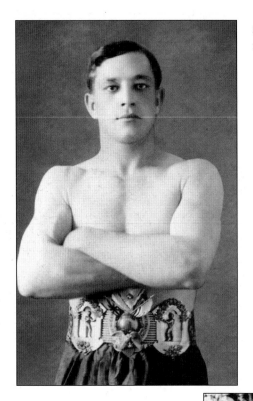

Stanley Ketchel poses with his world middleweight champion belt in 1908.

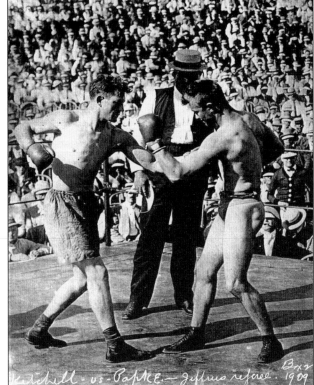

Stanley Ketchel (left) squares off in the ring with Billy Papke before their 1909 middleweight title fight at Colma Arena. In this fourth and final meeting between these two champions, Ketchel won a 20-round decision. Jim Jeffries refereed the contest.

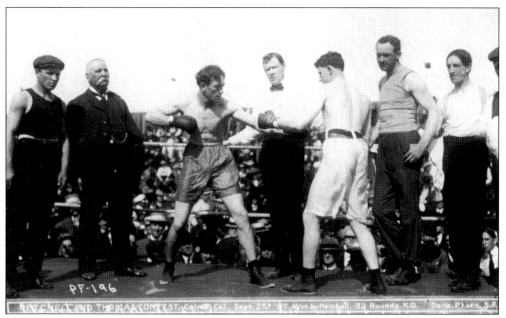

This Stanley Ketchel–Joe Thomas bout took place at Colma Arena on September 2, 1907. Ketchel won the fight with a Round-32 knockout to claim the world middleweight championship. (Courtesy of Gary Phillips.)

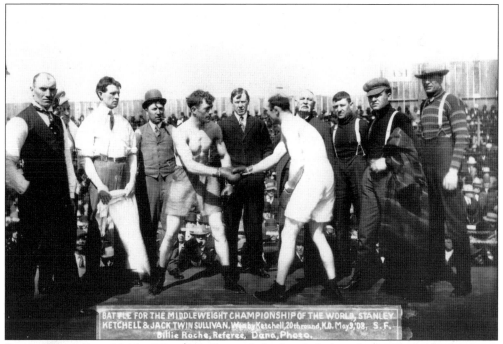

Stanley Ketchel and Mike "Twin" Sullivan shake hands before their May 9, 1908 fight at Coffroth's Mission Street Arena. Ketchel won by knockout in Round 20. Ketchel defended his claim as the middleweight champion in this battle.

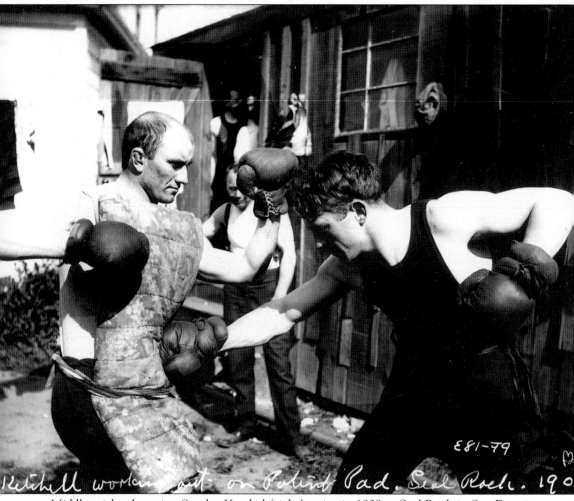

Ketchell working out on Patent Pad, Seal Rock. 190

Middleweight champion Stanley Ketchel (right) trains in 1909 at Seal Rock in San Francisco for his heavyweight title contest with Jack Johnson. Ketchel, "The Michigan Assassin," was born Stanislaus Kiecal in Grand Rapids, Michigan, in 1886, and began his professional career in 1903. Standing 5-feet, 9-inches tall and weighing 154 pounds, Ketchel fought the best middleweights and light-heavyweights of his era. In 1907, Ketchel had two fights in San Francisco with Joe Thomas. The following year, he knocked out the Sullivan twins, Mike and Jack, at Colma. After his win over Jack "Twin" Sullivan, Ketchel was recognized as the world middleweight champion. He had most of his title defenses in and around San Francisco. In 1908, he defended his crown in San Francisco against Joe Thomas. (Courtesy of Gary Phillips.)

This is the cover of *The Ring* magazine's December 1948 issue.

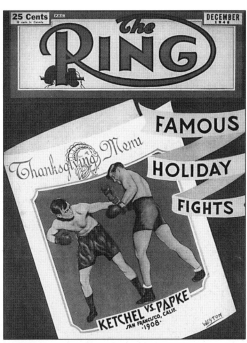

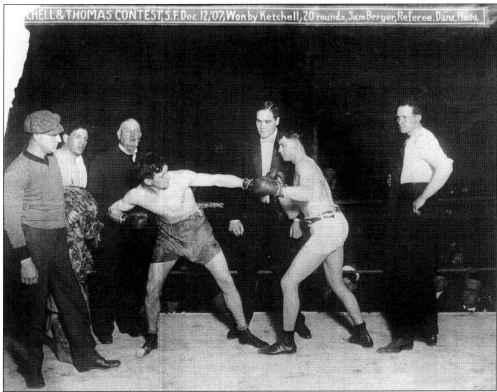

The December 12, 1907 fight between Stanley Ketchel and Joe Thomas took place at San Francisco's Recreation Park. Ketchel won a decision on points over 20 rounds to claim the world middleweight title. (Courtesy of Gary Phillips.)

After losing his title in a September 1908 rematch with Billy Papke in Vernon, California, "Rugged" Stanley Ketchel regained the crown at the Mission Street Arena that November. After defending his middleweight title at Colma against Papke in 1909, Ketchel challenged Jack Johnson for his world heavyweight championship in the same arena in October. He lost by knockout in Round 12. Stanley Ketchel was murdered in 1910 at the age of 24.

This is the last known photograph of Stanley Ketchel before his murder in 1910. "The Michigan Assassin" (second from left) is pictured with Pete Dickerson, outlaw Emmet Dalton, and boxer Joe Gorman. The photo was taken in Joplin, Missouri, in 1910.

"Terrible Terry" McGovern is shown here as featherweight champion in 1901. McGovern, the bantamweight and featherweight champion of the world, was born on March 9, 1880, in Johnstown, Pennsylvania. Undefeated as a bantamweight champion, McGovern moved up to featherweight and took the title from George Dixon in 1900. McGovern defended his featherweight title twice in San Francisco in 1901.

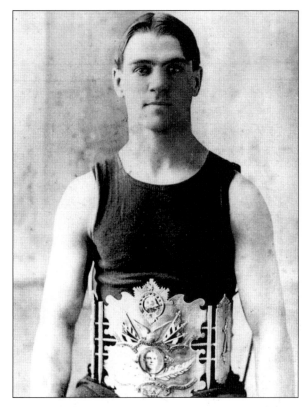

McGovern spars with "Professor" Mike Donovan. Donovan was the one-time world middleweight bare-knuckle champion who later became a renowned boxing instructor at the New York Athletic Club.

Terry McGovern (left) acts as a referee for a staged sparring session between Jim Corbett (middle) and heavyweight champion Jim Jeffries (right).

Joe Gans shows off his formal attire as the lightweight world champion in this photograph. Joe Gans, the "Old Master," is considered by ring experts as one of the all-time greats. (Courtesy of Gary Phillips.)

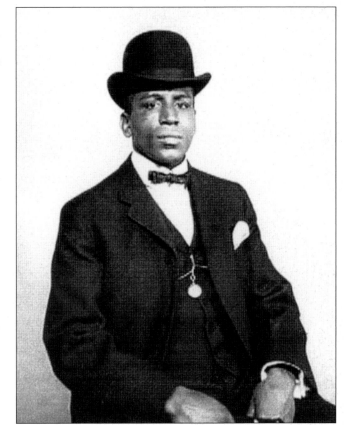

This photo shows "Baltimore" Joe Gans (right) challenging Battling Nelson for the world lightweight title. This Fourth of July 1909 fight at Colma Arena was won by Nelson in Round 17.

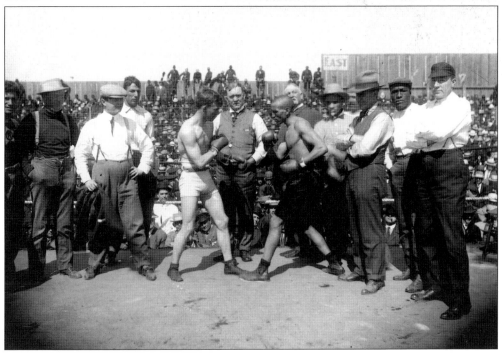

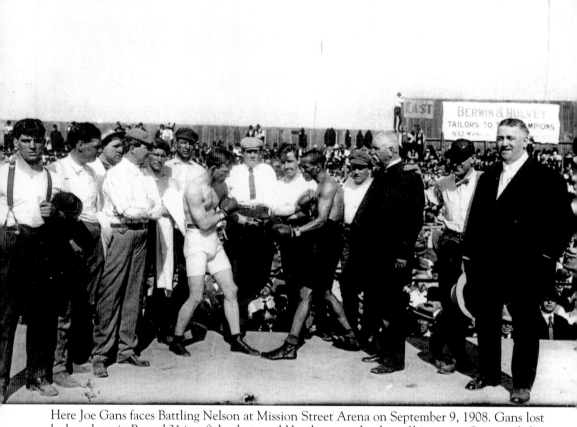

Here Joe Gans faces Battling Nelson at Mission Street Arena on September 9, 1908. Gans lost by knockout in Round 21 in a fight that would be the second to last of his career. Gans made his San Francisco debut in 1896 and fought there again in 1897. After winning the world lightweight title in 1902, Gans made his first title defense in San Francisco against George "Elbows" McFadden. In 1903, Gans defended his crown at Mechanics' Pavilion against Willie Fitzgerald and fought Joe Walcott and Jimmy Britt at the same venue the following year. Gans's other San Francisco appearances were against Mike "Twin" Sullivan and Jimmy Britt. In 1908, Gans lost two classic matches with Battling Nelson at Colma's Mission Street Arena. In his last three ring appearances, Gans was suffering from tuberculosis. He passed away on August 10, 1910, at the age of 35. (Courtesy of Gary Phillips.)

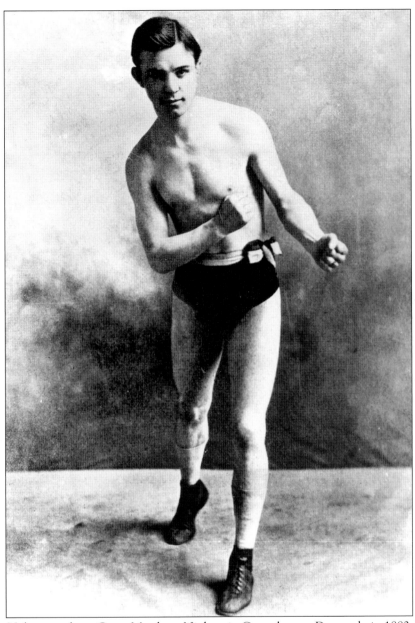

Battling Nelson was born Oscar Mattheus Nielson in Copenhagen, Denmark, in 1882. His first visit to San Francisco was in 1904 for four fights with local competition. He beat Martin Canole and Eddie Hanlon, knocked out Young Corbett II, and lost to Jimmy Britt in his bid for the vacant world lightweight title. In his 1905 rematch with Jimmy Britt at Mission Street Arena, the Dane won the lightweight championship of the world. In a third non-title bout with Britt in 1907, Nelson lost on points over 20 rounds. In 1908, Nelson fought a 15-round draw with Abe Attell in San Francisco and then scored two knockout wins over Joe Gans. In his next fight, Nelson knocked out "Fighting" Dick Hyland in 15 rounds. After losing his lightweight crown on February 22, 1910, to Ad Wolgast in Richmond, California, Nelson had two final contests in the Bay Area. He battled Anton LaGrave to a draw and lost to Owen Moran by knockout in November 1910.

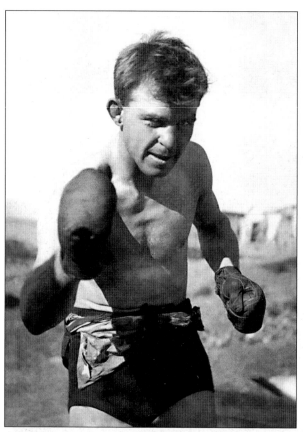

Battling Nelson, known as "The Durable Dane," had 132 professional boxing matches, winning 40 by knockout, in a career that lasted from 1896 to 1920. (Courtesy of Gary Phillips.)

Battling Nelson (left) shakes hands with Owen Moran in this photo. The Nelson-Moran bout took place at Blot's Arena in San Francisco on November 26, 1910. Nelson won by knockout in Round 11. (Courtesy of Gary Phillips.)

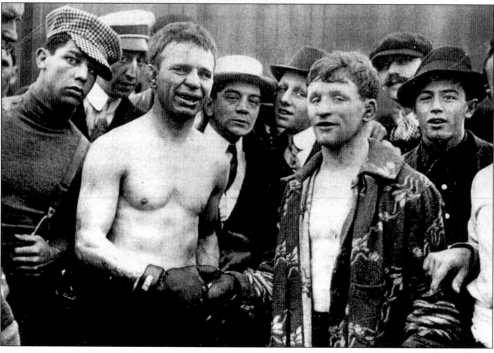

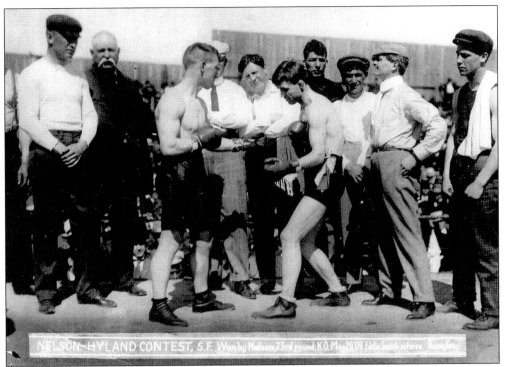

NELSON–HYLAND CONTEST, S.F. Won by Nelson, 23rd round. K.O. May 29 '09. Eddie Smith, referee.

Battling Nelson appears at center ring with Fighting Dick Hyland. Nelson won this 1909 lightweight championship bout at Mission Street Arena with a knockout in Round 23. (Courtesy of Gary Phillips.)

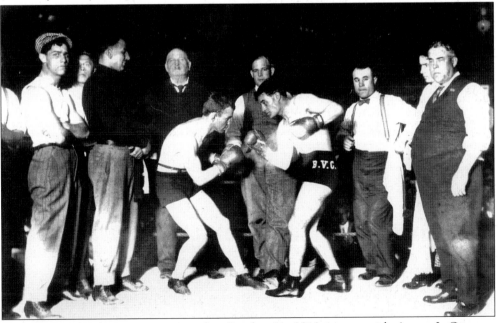

Nelson poses for the camera prior to his October 31, 1910 contest with Anton LaGrave at San Francisco's Broadway Athletic Club. The 15-round bout ended in a draw. (Courtesy of Gary Phillips.)

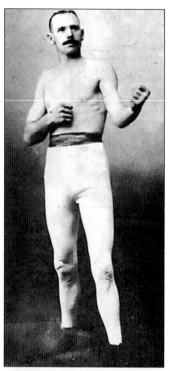

Robert Prometheus Fitzsimmons, or "Ruby Robert," is shown here in 1891 as world middleweight champion. Fitzsimmons made his San Francisco debut against "Sailor" Tom Sharkey in 1896 in a fight that was refereed by legendary lawman Wyatt Earp. Losing the heavyweight championship to Jim Jeffries in 1899, Fitzsimmons was knocked out in Round 8 of their 1902 San Francisco rematch. In November 1903, at the age of 41, Fitzsimmons became the first man in boxing history to capture titles in three weight divisions when he took the light-heavyweight championship of the world from George Gardner at Mechanics' Pavilion. Fitzsimmons retired from boxing in 1914 at the age of 52 and died 3 years later of pneumonia.

This is a photograph of the 1896 Fitzsimmons-Maher fight. Seconds after this photo was taken in Round 1 of Judge Roy Bean's Mexican ring battle, Peter Maher (right) was knocked out.

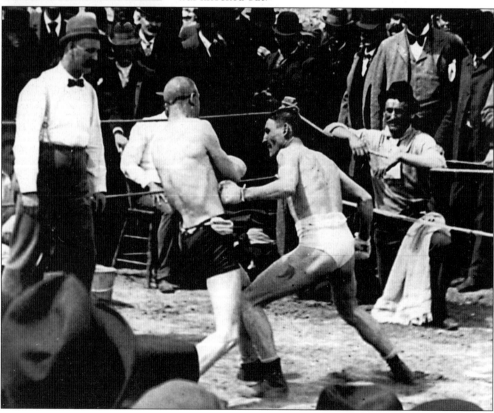

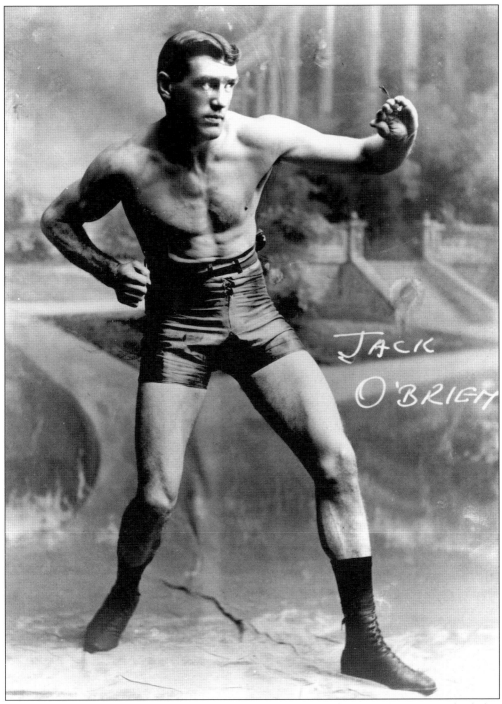

"Philadelphia" Jack O'Brien, a.k.a. James Francis Hagen, strikes a pose in 1905 as the light-heavyweight world champion. O'Brien has been called the fastest and most scientific boxer of his day. In January 1900, he fought a 15-round draw with Al Neill at Woodward's Pavilion. O'Brien then lost by technical knockout to "Young" Peter Jackson at the same venue one month later.

1905.

Jack O'Brien (seated) pauses for a photograph with trainer Jack Monroe in 1905. O'Brien fought in San Francisco in 1905, when he knocked out local favorite Al Kaufman in Round 17. In his next fight, "Philadelphia" Jack captured the light-heavyweight championship at Mechanics' Pavilion when he scored a Round-13 technical knockout over Bob Fitzsimmons.

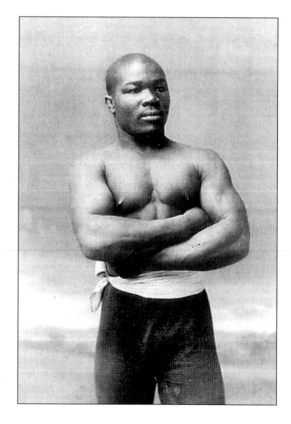

Joe Walcott, known as "The Barbados Demon," is shown here in 1901. Walcott is considered one of the greatest pound-for-pound fighters in ring history. In 1897, Walcott made his San Francisco debut with a knockout win over Young Corbett. In October of that year, the 5-feet, 2-inch tall Walcott challenged George "Kid" Lavigne in San Francisco for his lightweight crown, losing by technical knockout in Round 12. After winning the world welterweight crown from Rube Ferns in 1901, Walcott lost the title to "Dixie Kid" Aaron Brown on a controversial disqualification at Woodward's Pavilion in 1904. Walcott's last ring appearance in San Francisco was a draw against Joe Gans in 1904.

"Napoleon of the Ring" Jack McAuliffe is shown here as world lightweight champion. McAuliffe won the world lightweight crown in 1886 with a win over Billy Frazier, and in 1890 he defended his title in San Francisco against Jimmy Carroll. McAuliffe would have two additional contests in San Francisco before retiring from the ring undefeated in 1897.

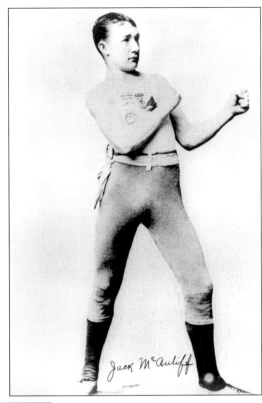

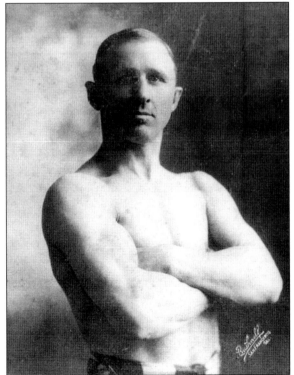

George "Kid" Lavigne poses here for a photo in 1900. Kid Lavigne, "The Saginaw Kid," began his career in Michigan in 1886. He had his first two fights in San Francisco in 1891 and 1892. After winning the lightweight title in 1896 against Dick Burge, he defended his title against Joe Walcott at San Francisco's Occidental Athletic Club in 1897. He was back in the city facing off against Tom Tracy in 1898 and "Mysterious" Billy Smith in 1899. After losing his crown to Frank Erne in 1899, Lavigne had one last ring appearance in San Francisco in 1902. Lavigne lost by technical knockout to a young, up-and-coming Jimmy Britt at Woodward's Pavilion.

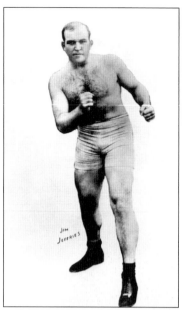

James J. Jeffries, "The Boilermaker," dethroned Robert Fitzsimmons to become the heavyweight champion of the world in 1899. As champion, Jeffries had all but two of his title defenses held in San Francisco, including his classic battles with Bob Fitzsimmons and Jim Corbett.

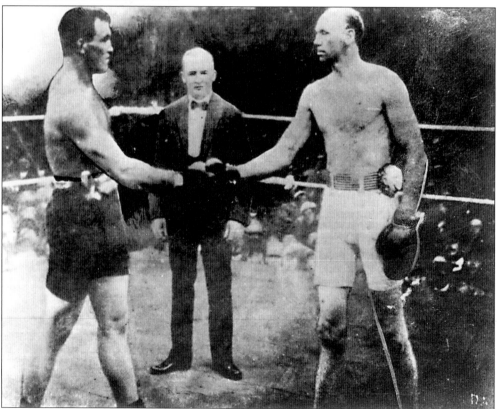

Jeffries and Fitzsimmons shake hands here before their June 9, 1899, title bout. Jeffries was a huge underdog in his title match with Fitzsimmons but was able to withstand everything the Cornishman had to offer. Jeffries knocked Fitzsimmons out in Round 11 to win the world heavyweight title.

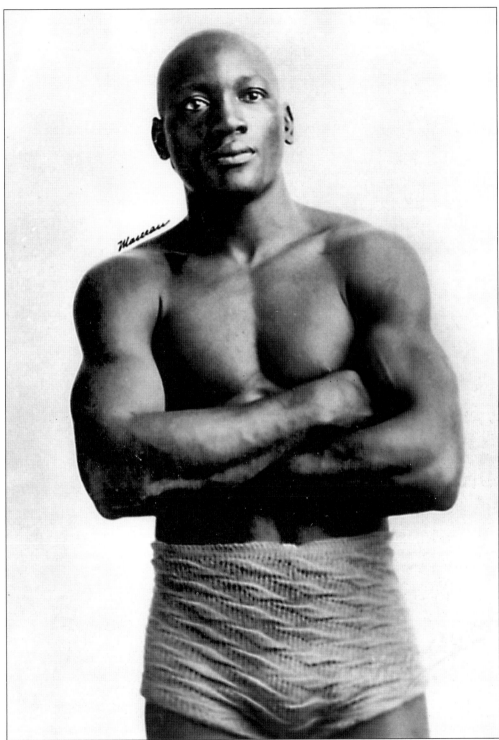

Nat Fleischer, founder and publisher of *The Ring* magazine, called Jack Johnson the greatest heavyweight champion in history.

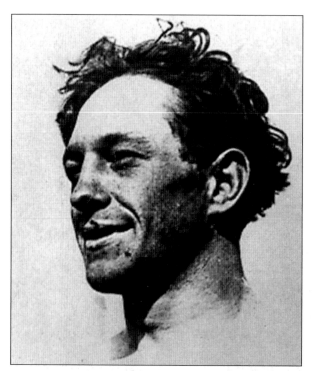

On October 16, 1909, middleweight king Stanley Ketchel challenged Jack Johnson for his heavyweight crown. Johnson won the fight that took place at Colma's Mission Street Arena, with a Round-12 knockout.

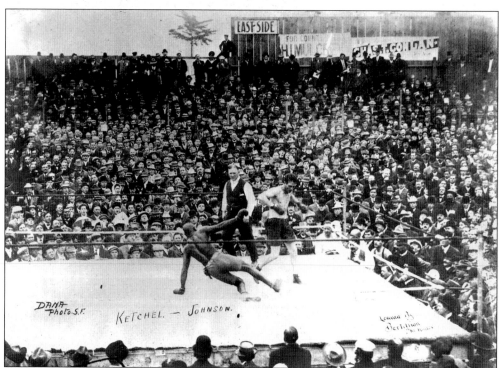

Jack Johnson hits the canvas from a Stanley Ketchel punch at Colma's Mission Street Arena in this October 16, 1909 shot. Ketchel scored this knockdown seconds before he was knocked out by Johnson. Ketchel lost two front teeth in the exchange from Johnson's well-timed uppercut.

Jack Johnson displays his powerful back during training at Seal Rock in 1909.

Jack Johnson is pictured here in 1908 as the new heavyweight champion. "The Galveston Giant" was born in Galveston, Texas, on March 31, 1878. As the first African-American heavyweight champion, Johnson is considered by many boxing experts to be the best defensive fighter in the sport's history. Johnson remained heavyweight champion from 1908 to 1915. During his career, Johnson had many of his classic matches in San Francisco.

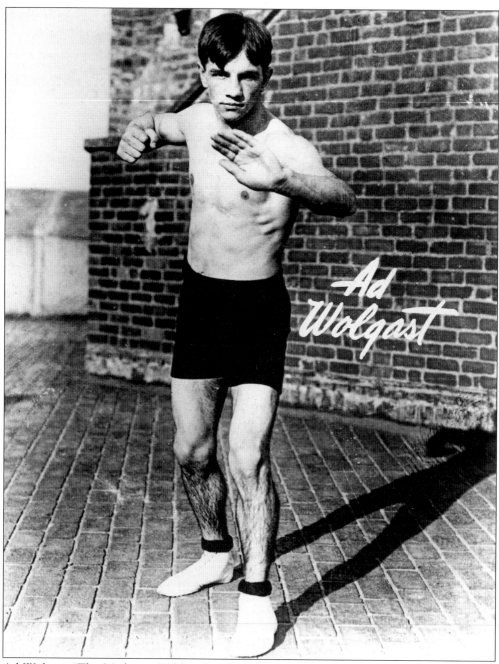

Ad Wolgast, "The Michigan Wildcat," is shown here in 1910. Wolgast was a scrappy fighter with great stamina and tremendous punching power. He began his pro career in 1906 and had his first fight in San Francisco in 1909, resulting in a decision over Lew Powell. Wolgast won the lightweight world title from Battling Nelson in Richmond, California, in 1910, defending it four times in San Francisco over the next two years.

In this 1911 photograph, Ad Wolgast trains in San Francisco.

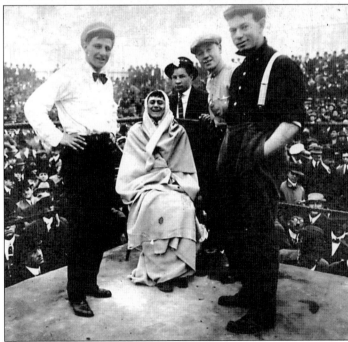

Willie Ritchie, covered in blankets, waits patiently in his corner for champion Ad Wolgast to appear during their bout in 1912.

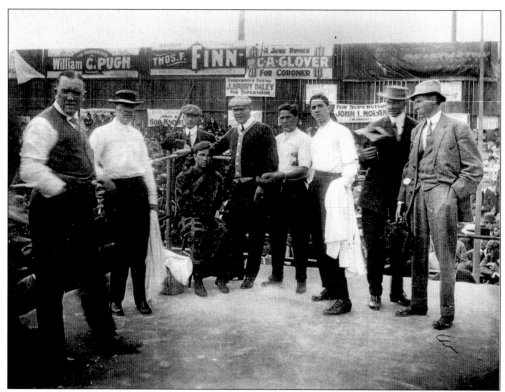

Ad Wolgast sits in his corner moments before the start of his title defense against Willie Ritchie at Colma's Mission Street Arena on November 28, 1912. Wolgast lost the world lightweight title to Ritchie on a Round-16 disqualification.

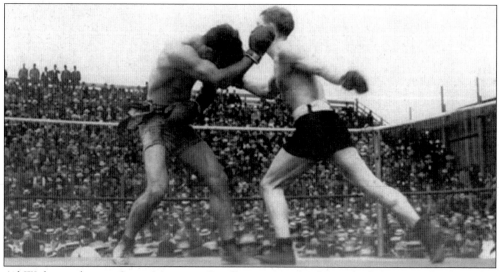

Ad Wolgast takes on Owen Moran in San Francisco in his last title defense on the Fourth of July in 1911. Wolgast retained his lightweight crown with a Round-13 knockout. In May 1912, he won a four-round decision against Willie Ritchie and then lost his lightweight title on a foul to Ritchie at Colma the following November. In his last San Francisco appearance in 1913, Wolgast split two fights with "Harlem" Tommy Murphy.

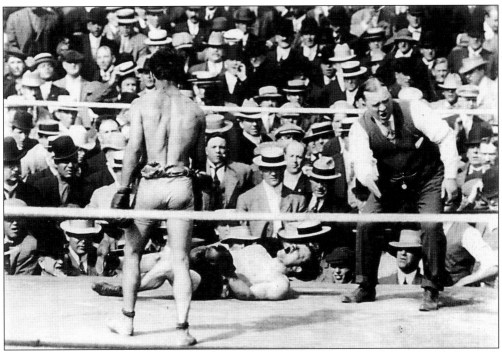

Owen Moran lays on the canvas gasping for breath in this shot. Wolgast's nonstop body attack ended the contest in Round 13.

Ad Wolgast is draped here in his robe after defending his lightweight title against Owen Moran in San Francisco on the Fourth of July in 1911. Tom Jones, Wolgast's manager, is on the left.

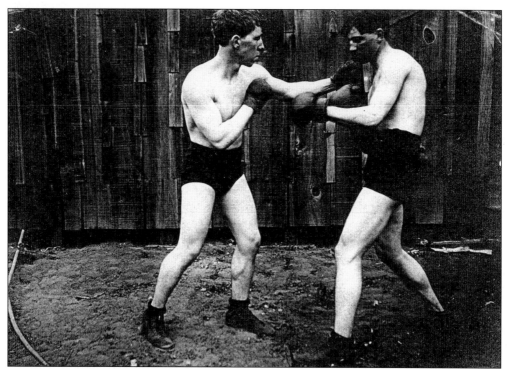

"Fighting" Dick Hyland spars with San Francisco's Frankie Edwards in this 1913 photograph.

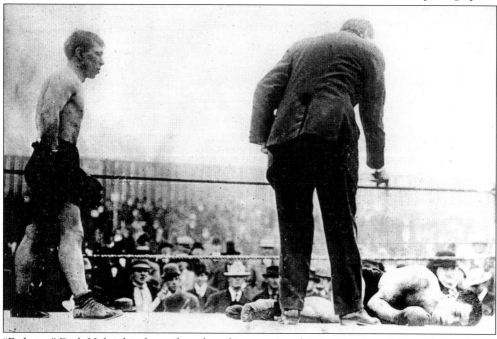

"Fighting" Dick Hyland is shown here knocking out Leach Cross in Round 41 at Colma Arena on June 26, 1909. Hyland was a frequent headliner in San Francisco during a career that spanned from 1903 to 1921. In his only shot at a world title in 1909, Hyland was knocked out by Battling Nelson at Mission Street Arena.

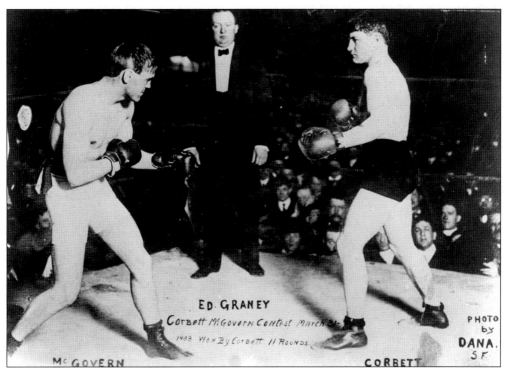

ED. GRANEY
Corbett McGovern Contest March 31
1903 Won By Corbett 11 Rounds.
McGOVERN
CORBETT
PHOTO
by
DANA.
S.F.

Young Corbett II (right) squares off with Terry McGovern at Mechanic's Pavilion in March 1903. Corbett won the featherweight world title from McGovern on Thanksgiving Day in 1901. In the return bout in San Francisco pictured above, Corbett again knocked out McGovern, this time in 11 rounds. Corbett was managed by ring announcer Joe Humphreys.

William J. Rothwell, known as "Young Corbett II," was the featherweight champion of the world in 1901. Corbett defended his title against Eddie Hanlon at Mechanics' Pavilion in 1903. In 1904, Corbett defended against Dave Sullivan in San Francisco, then lost a points verdict to Jimmy Britt there later in the year (at that time Abe Attell was recognized as featherweight world champion). In 1904 and 1905, Corbett was knocked out twice by Battling Nelson at Woodward's Pavilion. After a loss to Eddie Hanlon in 1905, Corbett resumed his career on the East Coast. Corbett's last ring appearance in San Francisco was a match against local favorite Johnny Frayne in 1909. Young Corbett retired from the ring in 1910.

Owen Moran shows a championship pose in 1911. Britain's Owen Moran battled some of the great San Francisco fighters of the golden age. Born in Birmingham, England, in 1884, he began his professional boxing career on New Year's Day, 1900. Nicknamed "The Fearless," Moran won the vacant bantamweight crown in 1907. Moving to the featherweight division, he became a San Francisco favorite. He fought Frankie Neil there in 1907, then had two draws with Abe Attell in 1908. After a loss to "Harlem" Tommy Murphy at Dreamland Rink in 1910, he defeated Battling Nelson at Blot's Arena in November 1910. His last ring appearance in San Francisco was his featherweight title loss against Ad Wolgast in 1911. (Courtesy of Gary Phillips.)

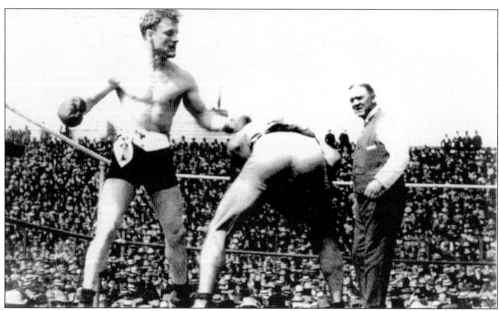

Owen Moran is shown here in action against Ad Wolgast on the Fourth of July in 1911.

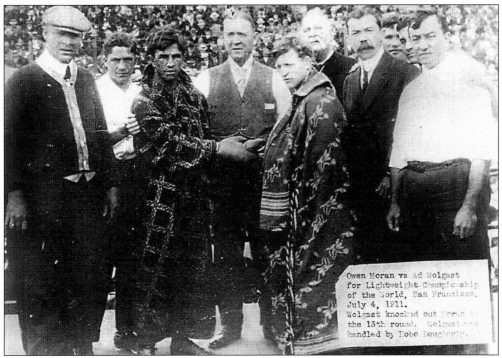

Owen Moran (right) shakes hands with Ad Wolgast before the start of their lightweight title fight in San Francisco on the Fourth of July in 1911.

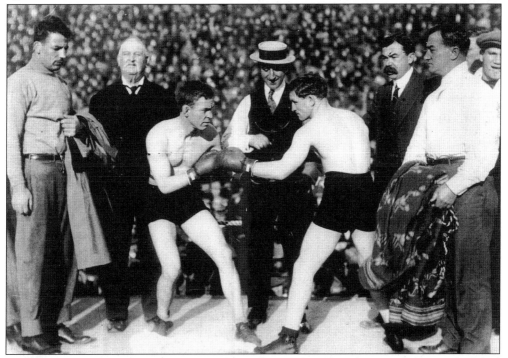

Owen Moran squares off for battle with Bat Nelson in this 1910 photograph. Moran knocked out Nelson in Round 11. (Courtesy of Gary Phillips.)

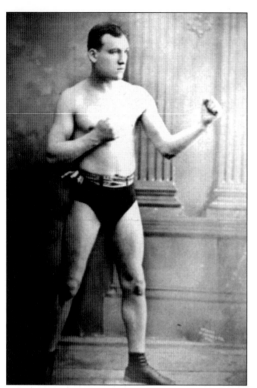

Shown here in the 1890s, "Mysterious" Billy Smith, also known as Amos Smith, began his professional boxing career in 1890, and in 1892 he came to San Francisco for a three-fight series against "no-name" opponents, winning two of them. In December 1892, Smith knocked out Danny Needham at San Francisco's Wigwam Theater and claimed the world welterweight title. Smith wore the crown until Tommy Ryan defeated him in 1894 in a bout refereed by Joe Choynski. Smith was back in San Francisco in 1896 for a no-contest affair against Billy Gallagher. After defending his title against Kid Lavigne at Woodward's Pavilion in 1899, Smith made one last ring appearance in the Bay City in 1911. A disqualification against Jim Cameron at Dreamland Arena. (Courtesy of Todd Ryan.)

"The Nonpareil" Jack Dempsey ruled the middleweight division between 1884 and 1891 and inspired his famous namesake, "The Manassa Mauler." Born John Kelly in Ireland in 1862, Dempsey made his pro debut in 1883. His first visit to San Francisco was in 1885 for a four-fight series, winning them all. Dempsey fought a draw there in 1886 and was back in town in 1889 for his first career loss to George LaBlanche. In his next fight, Dempsey won the world middleweight title at San Francisco's California Athletic Club, with a technical knockout over "Professor" Billy McCarthy on February 18, 1890.

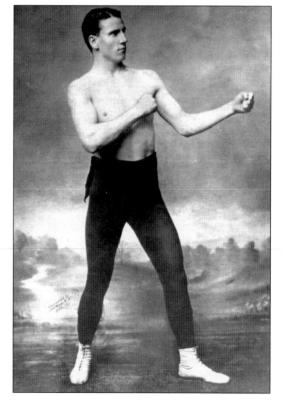

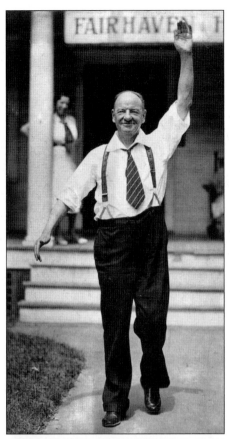

Joseph Edward Humphreys was perhaps the most famous ring announcer in history. In a career that spanned five decades, Humphreys announced over 20,000 fights. Joe Humphreys held aloft the hand of every heavyweight champion from John L. Sullivan to James J. Braddock. Humphreys also co-managed bantamweight and featherweight champion "Terrible" Terry McGovern and others.

Author Dan Somrack is pictured here with heavyweight champions Muhammad Ali, Joe Frazier, and Ken Norton.

George Gardner is shown here in 1903 as light-heavyweight champion of the world. George Gardner was born in Ireland and began his pro career in 1897 in the United States. Between July 1901 and October 1902, Gardner had seven bouts in San Francisco, including battles with past and future champions Joe Walcott, Jack Root, and Jack Johnson. After winning the light-heavyweight crown from Jack Root on the Fourth of July in 1903, Gardner lost it to Bob Fitzsimmons in San Francisco four months later.

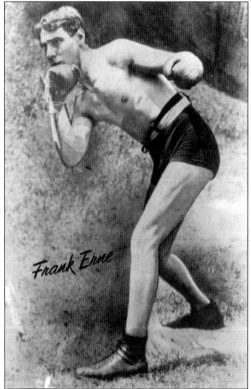

Frank Erne

Frank Erne won the featherweight title in 1896 from George Dixon before Dixon won it back in 1897. After lifting the lightweight crown from Kid Lavigne in 1899, Erne fought Dal Hawkins at Woodword's Pavilion in 1899. After losing the lightweight title to Joe Gans in 1902, Erne had one last fight in San Francisco later in the year—A KO loss to Jimmy Britt at Mechanics' Pavilion.

Ed "Gunboat" Smith was the "Great White Hope" heavyweight champion in 1914. Smith fought throughout his career in San Francisco. He began his career in 1909 and had several bouts in the Bay Area that year. In 1913, Smith defeated future heavyweight champion Jess Willard at Mechanics' Pavilion. In January 1914, Gunboat beat Arthur Pelkey and claimed the "White Heavyweight Championship." Smith lost two fights in 1917 with "The Manassa Mauler" Jack Dempsey at San Francisco and retired from the ring in 1921.

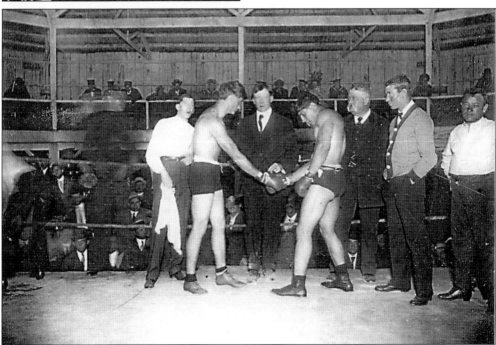

"Gunboat" Smith (left) shakes hands with Jim Barry before their May 1911 bout in Oakland. Barry won the fight on points over six rounds.

This 1910 photo shows George Dixon, or "Little Chocolate," the first universally accepted featherweight world champion. In 1890, Dixon won the featherweight crown from Nunc Wallace and defended his title in San Francisco against Abe Willis in 1891. Dixon was back in San Francisco in 1897 to fight against Dal Hawkins and lost his featherweight championship to Solly Smith there three months later. After regaining the world title in 1898, he lost it to Terry McGovern in 1900. Retiring from the ring in 1906, Dixon died penniless in 1909 at the age of 38.

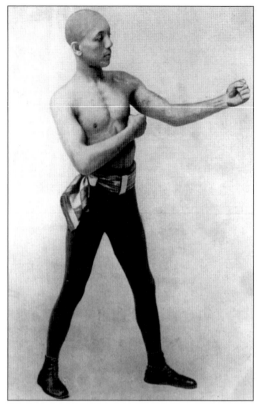

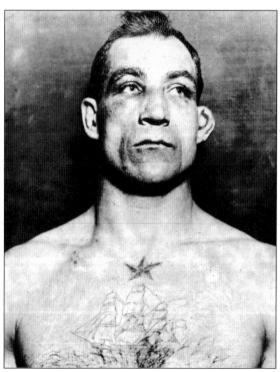

"Sailor" Tom Sharkey displays his cauliflower ear and famous star and ship tattoo. In 1895, Sharkey scored two knockout wins at Colma over John Miller and "Australian" Billy Smith. The following year, he made four ring appearances in San Francisco with wins over Alec Greggains, Joe Choynski, and Jim Williams. Sharkey then fought a four-round draw with Jim Corbett at Mechanics' Pavilion. Sharkey's next fight in San Francisco was against Robert Fitzsimmons. Though Fitzsimmons was ahead on points when he dropped Sharkey flat on his back in Round 8, the bout was halted by the legendary lawman Wyatt Earp and awarded to Sharkey. Serving as referee, Earp ruled that Fitzsimmons had fouled Sharkey. In his last main event at Mechanics' Pavilion, Sharkey suffered the first defeat of his career when he lost a decision to Jim Jeffries after 20 rounds.